IMAGES
of America

APALACHICOLA

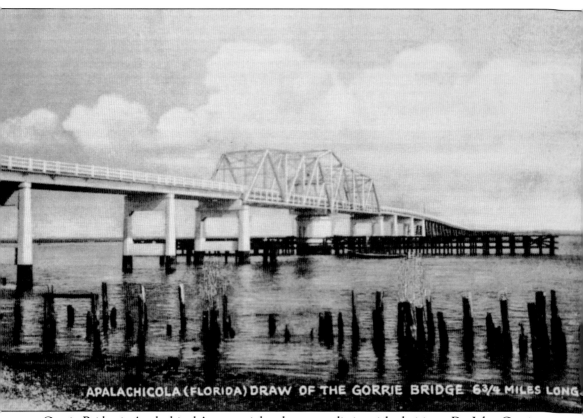

Gorrie Bridge is Apalachicola's memorial to her most distinguished citizen, Dr. John Gorrie (1803–1855), inventor of the artificial ice machine. Dedication ceremonies were held at the bridge on Armistice Day, November 11, 1935. Activities that day included a three-gun salute officially opening the bridge. Senators, congressmen, and other Florida officials were there. (Apalachicola Municipal Library.)

ON THE COVER: Queen Genivieve Pierce (backseat on the right with armful of flowers), who was crowned by King Retsyo as the 1916 Mardi Gras queen, is being driven by Homer Oliver with her maid of honor, Dorothy Sawyer. At left in the backseat is an unidentified woman, assumed to be the queen's mother or last year's queen. The car is a 1915 Buick, model C-55, seven-passenger touring car. (Fred Sawyer.)

IMAGES of America
APALACHICOLA

Beverly Mount-Douds

ARCADIA
PUBLISHING

Copyright © 2009 Beverly Mount-Douds
ISBN 978-0-7385-6817-1

Published by Arcadia Publishing
Charleston, South Carolina

Printed in the United States of America

Library of Congress Control Number: 2008942690

For all general information contact Arcadia Publishing at:
Telephone 843-853-2070
Fax 843-853-0044
E-mail sales@arcadiapublishing.com
For customer service and orders:
Toll-Free 1-888-313-2665

Visit us on the Internet at www.arcadiapublishing.com

A debt of gratitude goes to the Apalachicola Municipal Library, the Apalachicola Bay Historical Society, and Dolores Roux along with the families who made Apalachicola what it is today; their knowledge, guidance, and expertise made this the wonderful town it is. I want to dedicate this book to all of them.

Contents

Acknowledgments		6
Introduction		7
1.	Apalachicolians	9
2.	Glimpses and Glibs of Old Apalachicola	41
3.	Just for Fun	65
4.	Festivals and Celebrations	75
5.	School of Our Dreams	89
6.	Tour of Homes and Historic Landmarks	97
7.	Seafood, Lumber, Turpentine, and Bygone Years of Steam Boating	115

ACKNOWLEDGMENTS

I want to thank all the people of Apalachicola, but most of all, I thank Barbara Holmes and Ann Sizemore, the librarians, for showing and sharing all the wonderful photograph collections from Margaret Key, Jimmy Nichols, and Eddie Nesmith in the Apalachicola Municipal Library and for all their help in getting these photographs together for me. Along with the support and help from Bill and the Apalachicola Bay Historical Society, this means the world to me. But most of all, I want to thank my friends Bill Spohrer for putting the idea in my head and Dolores Roux for making this book come true. And as always, thanks to my best friend Marlene Womack for supporting me and just being there for me.

INTRODUCTION

In the mid-1800s, Apalachicola was a bustling shipping port in North Florida's Panhandle region. Many historic houses, inns, churches, and commercial buildings still remain.

The first steamboat sailed on the river in 1828. That same year, "Cotton Town" was named West Point by the Legislative Council of the Territory of Florida.

It was incorporated in 1829 with four councilmen. It was finally named Apalachicola in 1831. Some 33,000 bales of cotton were shipped in 1835, according to the *Apalachicola Gazette*.

The Port of St. Joseph was established in 1836 to escape the control of the Apalachicola Land Company. The Lake Wimico and St. Joseph Canal Company was formed to build what became a railroad (1839) from Iola to St. Joseph to draw the cotton trade from the Apalachicola River.

This was Florida's first railroad. Florida's Constitutional Convention was held in St. Joseph in 1838. St. Joseph was not able to compete with Apalachicola, however, and major storms in 1837, 1839, and 1844, along with a yellow fever epidemic in 1841, destroyed the town.

A number of homes moved by barge from St. Joseph in 1844 are still standing in Apalachicola. It is estimated that 150 people lived in West Point in 1828 and 2,000 in 1838. However, the population would fluctuate according to trade and yellow fever conditions.

Cotton was shipped from December through June, with most of it shipped from January through March. In 1836, some 50,000 bales of cotton were shipped from Apalachicola. It became the third largest cotton port on the Gulf Coast, ranking after New Orleans and Mobile.

These vessels would go to New England, England, France, Belgium, or wherever there were cotton mills or lace manufacturing centers. They tended to sail a triangular route among Boston or New York, Apalachicola, and Liverpool or Le Havre. There were foreign consulates in Apalachicola. Goods were also shipped upriver to towns and plantations.

By the 1850s, the waterfront was lined with brick warehouses and broad streets to handle the loading and unloading of cotton. Steamboats laden with cotton came down the river and were unloaded. Then small shallow-draft schooners (lighters) shuttled the cargo to ships moored offshore.

As the railroads expanded throughout the United States, a new industry took shape in the city. Home to large cypress forests, Franklin County developed several big lumber mills in the late 1800s. Lumber magnates built many of the magnificent historic homes that line our streets.

By the end of the 19th century, oysters and seafood became an important industry. Today Franklin County harvests more than 90 percent of Florida's oysters and 10 percent of the oysters consumed in the nation. Shrimp, blue crab, and finfish are also very important commercially, bringing in over $11-million worth of seafood to Franklin County docks annually. Apalachicola has celebrated "Oyster Day" since 1914.

Among the family names in the city, some were Orman, Scheolles, Taranto, Martina, Raney, Porter, Gorrie, Chapman, and Grady. Florida became a state in 1845.

Apalachicola, like many other Southern cities, had established a Mardi Gras celebration. The custom was continued until 1916 and then was abandoned. The reigning monarch of the

celebration was termed King Retsyo ("Oyster" spelled backward) and was described as the "Son of Neptune," guardian of inland waters, bays, and estuaries. The opening ceremony usually saw King Retsyo and his royal coterie arriving by steamboat to open the ceremonies. In 1916, King Retsyo II arrived via steamboat at the Tarpon dock in Apalachicola on Thursday, March 2, being greeted by "huzzas" and music of many bands. In addition to being given the keys to the city, King Retsyo attended a coronation ball and a fancy dress masque ball.

Apalachicola organized the first seafood festival, known as Harbor Day, in 1946. It was promptly pushed forward by Newt Creekmore, Apalachicola's city manager at that time. Apalachicola Seafood became the new name for the festival in 1963. The Florida Seafood Festival, as it is known now, is the largest maritime festival in the state of Florida, and that name changed during the 1970s.

KEY TO PHOTOGRAPH SOURCE ABBREVIATIONS:
Fred Sawyer—FS
Frank Cook—FC
Bill Spohrer—BS
Patsy Hays Philyaw—PHP
Dolores Taranto Roux—DTR
Rex Buzzett—RB
Apalachicola Municipal Library—AML
Linda Glover—LG
Dawn Radford—DER
Apalachicola Bay Chamber of Commerce—ABCC
Ruth Hall Schoelles—RHS
Despina Williams—DW
Martha Pearl Ward—MMW
Susan Buzzett Clementson—SBC
Wesley Chesnut—WC
Voncille Sangaree McLeod—VSM
Faye Parker Tarantino—FPT
Dorothy Porter Hill—DPH
Mark Curenton—MC
Holley Lemon—HL
Dixie Partington—DP
Brittany Alford Beauchamp—BAB
Dimples Johnson Poloronis—DJP
Lucille Silva Saker—LSS
Olga Nichols—ON
Louie Van Fleet—LVF
Lisa Zillgarelli—LZ
Holley Lemon—HL
Brittany Alford Beauchamp—BAB
Beverly Mount-Douds—BMD
Robert Nedley—RN
George Watkins—GW
Dave Maddox—DM

One

APALACHICOLIANS

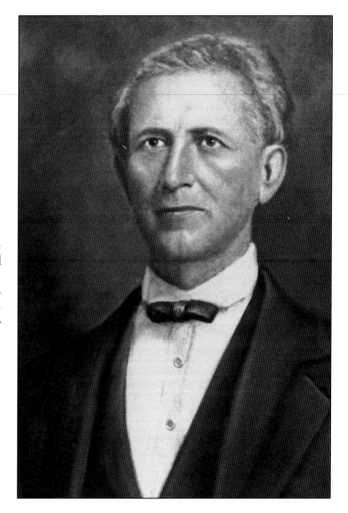

Abraham K. Allison was the president of the Senate in 1865 when Gov. John Milton committed suicide, making Allison the sixth governor of Florida. He served from April 1 to July 13, 1865, when the Union army came and took over Tallahassee. Allison was a businessman and politician. He served in the Florida Territorial Legislature and the Florida State House of Representatives. Allison was born December 10, 1810, in Jones County, Georgia. He worked as a merchant in Columbus, Georgia, before moving to Apalachicola, where he served as the city's first mayor. He also served as the first county judge of Franklin County and as the clerk of the U.S. Court. In the Seminole War, he was captain of the Franklin Rifles. His death occurred on July 8, 1893, in Quincy, Florida. (AML.)

Minnie Barefield, a mulatto lady, lived with Charles Dobson, a lumberman, who had a house built in 1907 for her. This house was almost a copy of the Coombs house and believed to have been built by the Marshall Brothers. It has beautiful stained-glass windows, eight fireplaces, imported tile, and elaborately carved mantels. Minnie lived here until her death in 1917. (RHS.)

Jimmy Bloodworth played professional baseball for 11 years from 1937 to 1951. Bloodworth played 1,002 games, hit 62 homers, and had a .248 lifetime batting average while playing for the Washington Senators, Detroit Tigers, Pittsburgh Pirates, Cincinnati Reds, and the Philadelphia Phillies. Bloodworth left a big mark on this town; the school baseball field was named for him. Other members of Jimmy's family also played sports here. (DPH.)

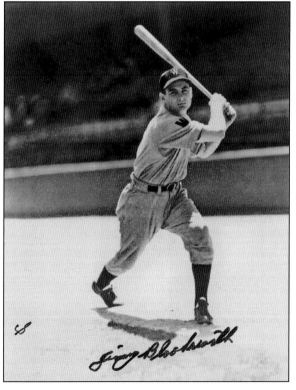

Sitting here is Elizabeth Boyd Buzzett, the mother of six-month-old Susan Buzzett Clementson. Here they are in the home of Billy and Betty Buzzett on Bay Avenue in Apalachicola. This was during the Christmas holidays in December 1943. (SBC.)

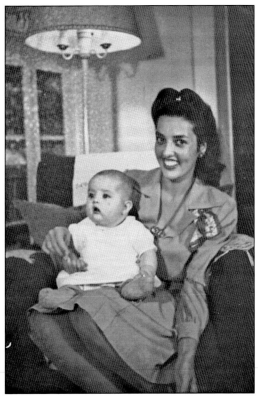

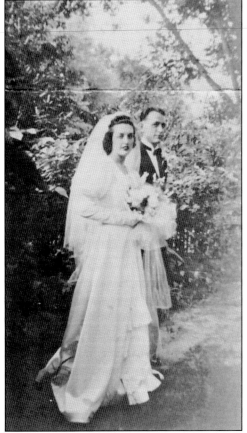

This is a wedding photograph of William C. Buzzett and Elizabeth Boyd Buzzett on June 4, 1939, on the front lawn of the "Steamboat House," formally known as the Porches. Elizabeth was boarding here when she met and married William while teaching school in Apalachicola. (SBC.)

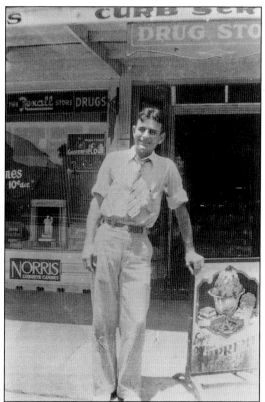

Juilian "Rex" Buzzett stands in front of Buzzett's Rexall Drug Store. First Lt. J. R. Buzzett entered the local National Guard in 1940 and was one of five brothers who served in World War II. Rex, a member of the 327th Engineer Combat Battalion, was killed at Utah Beach during the invasion of France on D-Day, June 6, 1944, the same day brother Harry Buzzett graduated from West Point. (RB.)

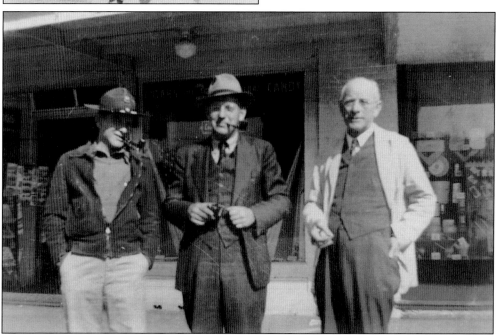

From left to right, Rex Buzzett, Dr. August E. Conter, and William D. Buzzett, the founder of Buzzett's Drug Store in 1905, stand in front of the Apalachicola, Florida, pharmacy. This photograph was taken before World War II, just before Rex was killed. (SBC.)

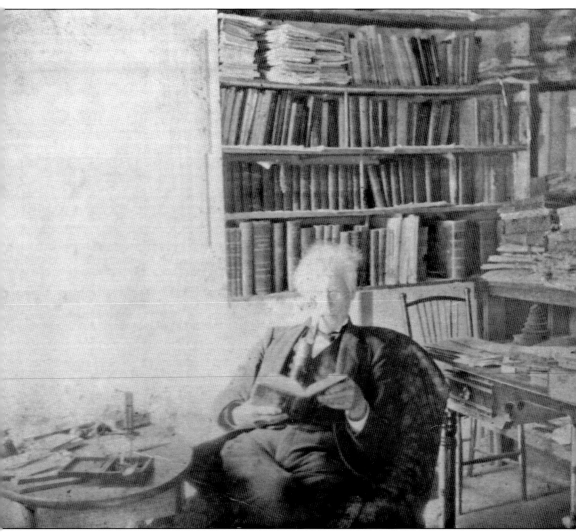

Dr. Alvan Wentworth Chapman was a well-known botanist and the author of *Flora of the Southern United States*, published in 1860. He came to Apalachicola about 1847; he was a surgeon and a clever physician. Dr. Chapman stood over 6 feet tall, and his hair was that of the fine white texture likened to snow. He eyes were clear and blue and with all the enthusiasm and purpose of youth in their glance. He was a dandy and always wore dark-blue suits. He was insistent that he was a New Englander; his profile spoke of that hardy Puritan stock. In 1847, he settled in Apalachicola, where he practiced medicine for more than half a century. He married in November 1839 to Mary Ann Hancock. Dr. Chapman died at Apalachicola on April 6, 1899, in his 90th year. (AML.)

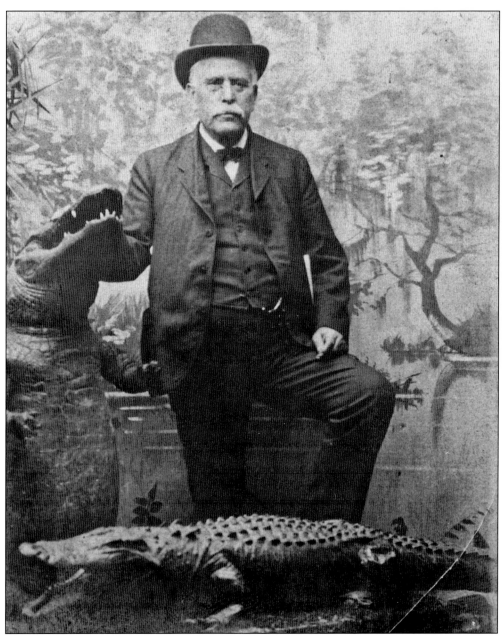

James Nathaniel Coombs, a successful entrepreneur, was recognized as the wealthiest man in town for his ownership of three sawmills, the First National Bank of Apalachicola, and the Coombs Company, exporter of pine and cypress lumber to destinations around the world. Coombs married Maria A. Starrett. They moved to Pensacola in 1871 where Coombs worked in the timber business. In 1877, they moved to Apalachicola. Increased demand for lumber brought success to Coombs and enabled him to set up the Franklin County Lumber Company in Apalachicola and nearby Carrabelle. With his business success, Jim Coombs did not neglect his political interests. He was an active member of the Republican Party and attended Republican Party conventions. However, he declined to accept his party's nomination for governor in 1900 and was briefly promoted as candidate for the U.S. vice presidency in 1908. (BS.)

Demo George, born Demosthenes George Magomenos, was born in Trikeri, Greece, in 1874 and emigrated to the United States in October 1900. A gifted boatbuilder, George crafted a number of boats. George founded the West Point Oyster Company and, later, the Standard Fish and Oyster Company. George built a fleet of shrimp boats, naming them after his sons and his wife and daughters. (DW.)

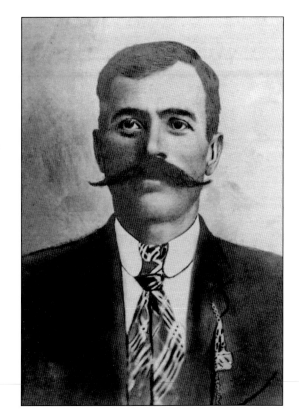

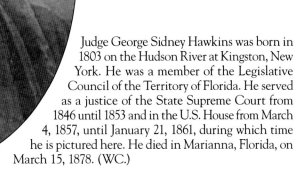

Judge George Sidney Hawkins was born in 1803 on the Hudson River at Kingston, New York. He was a member of the Legislative Council of the Territory of Florida. He served as a justice of the State Supreme Court from 1846 until 1853 and in the U.S. House from March 4, 1857, until January 21, 1861, during which time he is pictured here. He died in Marianna, Florida, on March 15, 1878. (WC.)

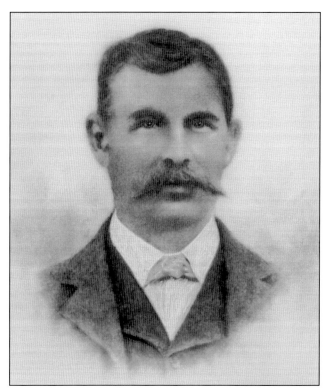

William Henry Gibson served as city marshal in the early 1900s and was father to Arthur B. Gibson (deputy sheriff), Mary Ella "Sunshine" Gibson, and Annie Gibson Hays. He was husband to Mary Ella Byrd Gibson. (PHP.)

Mary Ella "Sunshine" Gibson never married. In the early 1900s, Sunshine was a part-time schoolteacher. In 1923, she and her sister Annie bought out the Franklin Hotel, renamed it the Gibson, and ran the hotel for many years. (PHP.)

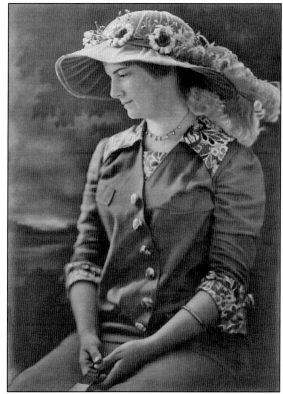

Mary Ella Byrd married William H. Gibson in Columbus, Georgia, before coming here in 1899. She ran an exclusive home service in Apalachicola: she offered home cooking and all the modern conveniences one could expect in 1916. Her business was located next door to the First Methodist Church. Rates in those days were only $2. (PHP.)

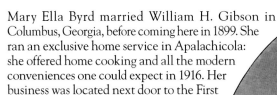

Elizabeth Elgin Wefing Hatch moved to Apalachicola with her son George around 1870. They moved here from Pittsburgh, Pennsylvania; she was a widow of the Civil War. (LG.)

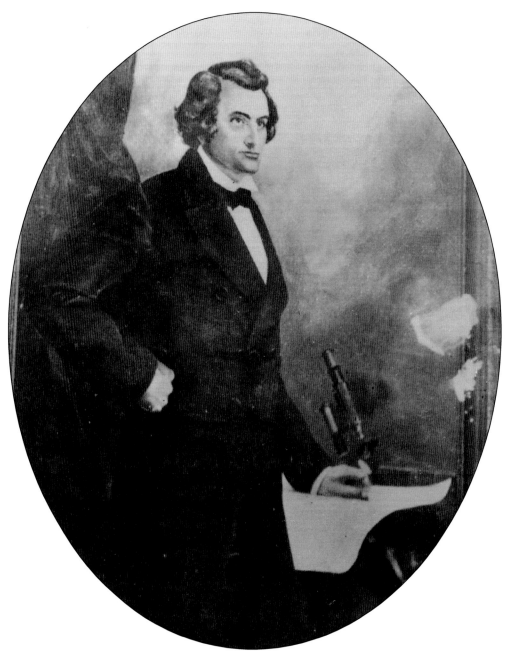

Dr. John Gorrie was born in Charleston, South Carolina, on October 3, 1803. He settled in Apalachicola as a physician in 1833 and resided there until his death on June 18, 1855. He was a postmaster, city treasurer, city councilman, and secretary of the Masonic Lodge. Dr. Gorrie first experimented with the making of artificial ice, finally succeeding and demonstrating it in the presence of guests in 1850, for which today his statue is placed in the Hall of Fame in Washington, D.C. John Gorrie was sometimes called the "Father of modern refrigeration." Seeking aid for his Apalachicola yellow fever patients in the 1840s, Gorrie invented a rudimentary refrigeration machine that produced artificial ice. He obtained a patent in 1851 but never realized his dream of developing the machine before his death four years later. (RHS.)

Edward Ryan Hays, born around 1907 in Greenwood, South Carolina, married Kathleen Reams, a schoolteacher from Greenville, Florida, on August 30, 1933, in Apalachicola. Edward and Kathleen helped Sunshine Gibson, his aunt, run the hotel after his mother, Annie, married C. B. Palmer and moved to Tallahassee, Florida. (PHP.)

Kathleen Reams Hays came to Apalachicola around 1933, staying at the Porches Hotel while teaching school here. She met and married Edward Hays the same year. They had one daughter, Patsy Hays, and she married James Philyaw from Port St. Joe, Florida; they had two sons. (PHP.)

Rebecca Hickey was a true daughter of the South and widow of Joseph Patrick Hickey. Rebecca Hickey was born in Apalachicola in 1875 and was a member of the Trinity Episcopal Church; she was president of the woman's club for over 15 years, vice president of the Daughters of the American Revolution, and president of the St. Anne's Circle. Hickey proudly stood for civic growth and betterment of the town. (AML.)

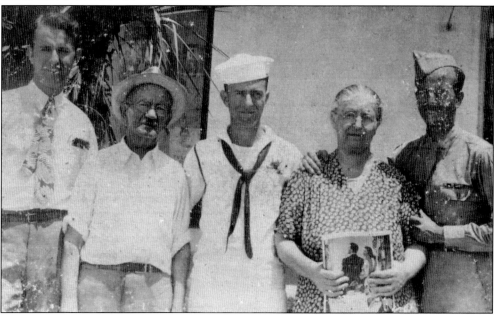

Many Greek immigrants came to Apalachicola in the early 1900s. The Nichols family was one of them. From left to right are Dr. Photis Nichols, John Nichols, Nick Nichols, Garouphalia Nichols, and Jimmie Nichols. The family ran a business that carried a variety of groceries and dry goods. It was called Economy Cash Store. Jimmie Nichols served over 16 years as mayor and was responsible for many changes in the town. He died in August 2009. (ON.)

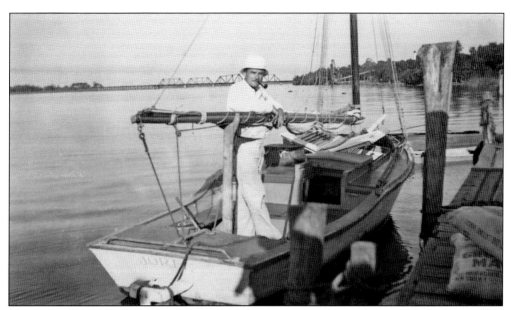

Alexander Key was born in Maryland, attended a military academy in Georgia, and later attended the Chicago Art Institute. His first illustration job was for *The Light of Myth*. During the Depression, he wrote stories as a way to get his art commissions. His first wife was Margaret H. Livings; they bought a Victorian mansion, later known as the Key House. Here Key is aboard the *Joree* heading up the Apalachicola River. (AML.)

Margaret Harmony Livings Key was an author and supported herself for more than half a century by serving as a reporter and writing historical articles for numerous magazines. Margaret met Alexander Key in art school and married him. She was a very well-educated, intelligent, independent, and outspoken woman. During her later years, Margaret and her sister, Bess Less, lived in her house until they were well into their 90s. The late Margaret Key directed in her will that upon the sale of her estate the proceeds be given to the Apalachicola Municipal Library board, of which she was a longtime member. (AML.)

John Maddox, son of William Sanders Maddox, moved his family from Apalachicola to the St. Joseph Bay area of Gautier Hammock in 1893. They returned to Apalachicola in 1898. John and his wife, Charlotte Wall of Cheltenham, England, had four children: Fred, Eva, Roy, and Alice. John served in the U.S. Navy during the Spanish-American War and later became the first harbor pilot for the Port of Port St. Joe. (DM.)

Fred Maddox moved with his parents, John and Charlotte, to the St. Joseph Bay area of Gautier Hammock and later relocated to Black's Island. Following the profession of his father, Fred became a harbor pilot. He served with the American Expeditionary Forces in France during World War I. In December 1920, Fred married Zola McFarland, and they established their home site on St. Joseph Bay, now designated as Maddox Park. (DM.)

Mary Isabelle Stewart Marks was the first white girl to be born in the Old City of St. Joseph, Florida. This was in February 1838. In 1841, yellow fever raged St. Joseph and the family moved to Apalachicola. Mary's mother, Emily, was the best-educated woman in that area; she opened Mrs. Stewart's Private School for Young Ladies. In 1855, Mary met and married her husband, Charles Ferdinand Marks, and raised two children. (LG.)

George H. Marshall, his father, John, and his brother Herbert built most of the houses in Apalachicola between the years 1890 and 1920. George was a contractor, a carpenter, and a man who could do magic with wood. The Marshalls owned and operated a lumberyard and milling company in Apalachicola. George also had a hand in moving the Cape San Blas Lighthouse tower inland in 1909, where it stands today. (GW.)

Herbert O. Marshall married Pearl Porter, daughter of Edward Porter, lighthouse keeper at St. George Island. Herbert (left) and Pearl married in October 1923, just after Herbert got out of the navy. Herbert went to work for the state road department, did some carpentry, and was sheriff of Franklin County for 16 years. Herbert was killed in a boating accident on the island in September 1976. He is pictured here with Gov. Leroy Collins (right) of Tallahassee. (AML.)

Voncille Sangaree McLeod, a lifelong resident of Apalachicola, was born during the height of the fighting in World War I. When one meets this dynamic, beautiful, 90-year-old woman with clear blue eyes the color of a perfect sky, it is easy to understand why she is known as the "Queen of Apalachicola." Voncille graduated from high school in 1936 and married Carroll McLeod. Voncille and Carroll had two sons: James C. Jr. and Rodney McLeod. (VSM.)

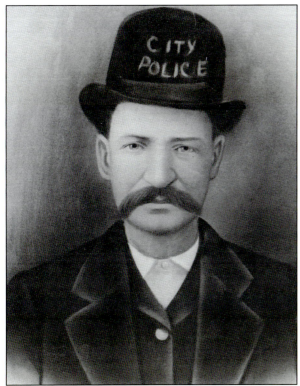

Patrick Nedley was born in 1851 in Ireland. His family came to Apalachicola just before 1860; his father, James, was in the Civil War and passed away shortly before 1870. Patrick married around 1870 and took care of his widowed mother, Ann, for her remaining life. Patrick and his wife, Felicia Rodriquez Nedley, had six children. Patrick was a fisherman, sailor, and policeman who died in 1901 in Apalachicola. (RN.)

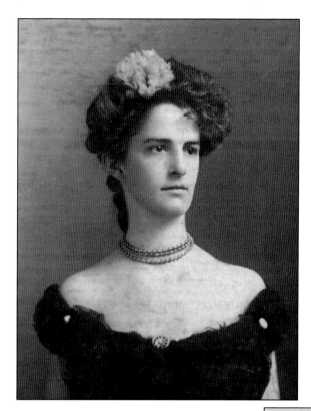

Annie Gibson Hays Palmer married Alfred Gordon Hays and moved to South Carolina. After the death of her husband, Annie and her two-year-old son, Edward, moved back to Apalachicola to be with family. Annie and her sister Sunshine bought the Franklin Hotel and renamed it the Gibson. About 1925, Annie married C. B. Palmer and moved to Tallahassee. (PHP.)

Emily "Miss Po" Porter was the daughter of Richard Gibbs Porter Jr. and Steppie Irene Rice and sister to Richard Gibbs III and Edward Swindell Porter. Emily Porter was a truly dedicated schoolteacher and much loved by all at Chapman High School. The 1956 Chapman High yearbook was dedicated to "Miss Po" as their beloved sponsor and again in 1958 and 1959 "In grateful recognition of her work" by all seniors. (AML.)

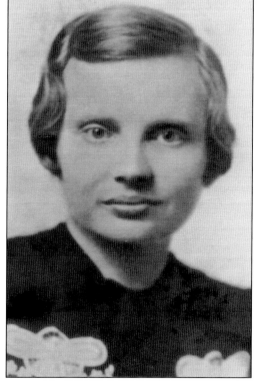

Josephine Mirabella Poloronis was the mother of Alfia, Angelina, and Johnnie Mirabella. She was the wife of Stratis Poloronis and "momma" to Olympia and Pete Poloronis. She and Stratis also raised Mary Chiarenza Dean. This was a loving Greek family of great cooks and good seamen. "Momma Josephine" was well known for making her meatballs every Sunday. (DJP.)

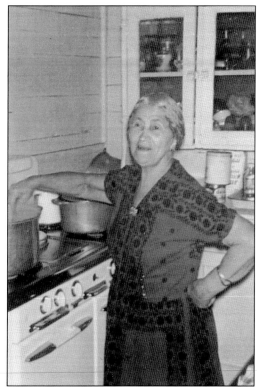

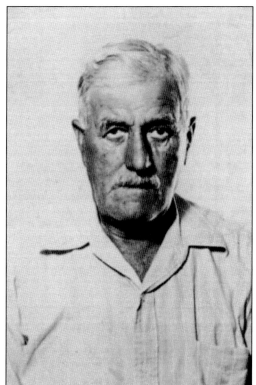

Stratis Poloronis came from Greece and died in Mobile, Alabama, in 1952. He was a commercial fisherman who oystered, shrimped, and fished. Stratis was well known by the Greeks in Irish Town for cooking a 16-layer cake with olive oil in a frying pan. He was the cook on the snapper boat *Eumorphia* with Capt. George Mosconis. Everyone also loved his lemonade and lemon-fish soup. (DJP.)

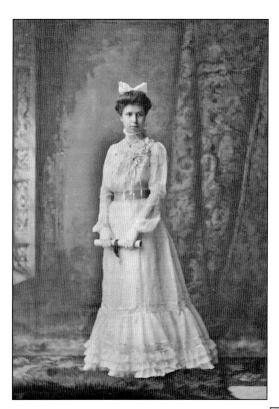

Marietta Ida Porter, known as "Metta," was born April 29, 1885, the daughter of Thomas Francis Porter and Georgia Ida Stow. Metta graduated from Apalachicola High School and later again in Connecticut, returned home, and married John Henry Cook in 1909. They had three children: John Francis, Margaret Porter, and Ida Janet Cook. (FC.)

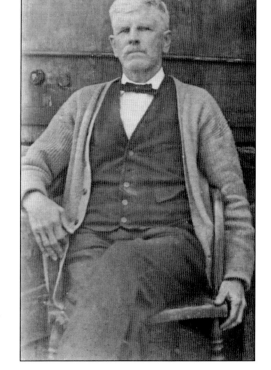

Richard "Dick" Henry Porter (1849–1918) was born in Apalachicola, the second son of Richard Gibbs Porter and Mary Tibbits Salter. Porter also served as clerk of the circuit court in Apalachicola, Florida. He married Virginia Raney, and they had six children. (DPH.)

Virginia Raney Porter (1852–1942), born in Apalachicola, was the youngest daughter of David Greenway and Harriet F. (Jordan) Raney. Virginia married Richard ("Dick") Henry Porter in 1880. Their children were Harriet Frances, Mary Tibbits, Virginia Raney, Richard Henry Jr., Elizabeth Lamar, and Gilbert Rodman Porter. (DPH.)

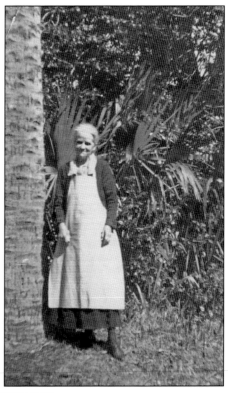

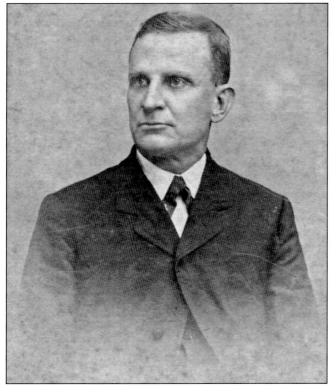

George Pettus Raney was born in 1845 in Apalachicola. George has given more than 25 of his 42 years of manhood to the service of his native state. In 1868, at the age of 22, he was elected to represent Franklin County in the House of Representatives and in 1869 the legislature, and he became the chief justice of the Florida Supreme Court. Judge Raney married in 1873 and had four children. (DPH.)

Dolores Taranto Roux was the daughter of Joe and Magdalene Taranto. Dolores graduated Chapman High School in 1955, was in the band and a cheerleader, married Louis Roux, and had two children. Today she owns and operates Dolores Sweet Shoppe and Restaurant in Apalachicola. (BMD.)

Fannie F. Ruge, wife of John G. Ruge, was a charter member of the Philaco Club before 1897. She was very much involved in local charitable work. After John Ruge passed away, she later married A. B. Chaffee. She died in the 1940s and is buried in the Chestnut Cemetery beside Ruge. (LG.)

George Henry Ruge, married to Elizabeth P. Porter and brother to John G., led the drive to secure a railroad for shipping, lumber, oysters, and fish to northern and western markets. Together the boys helped their father, Herman, establish a hardware store and machine shop. In 1885, the business became Ruge Brothers Canning Company. (AML.)

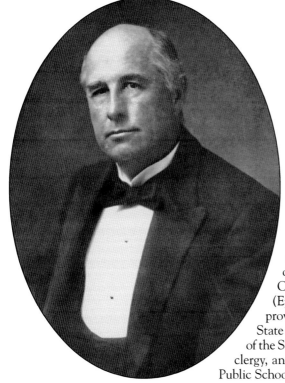

John G. Ruge was married to Fannie. Born in 1854, he died in 1931. The Ruge brothers own an oyster canning company and had Coca-Cola holdings, along with other interests. They helped build the Chapel of the Resurrection and Ruge Hall (Episcopal) at Florida State University, provided scholarships to the then Florida State College for Women and the University of the South, provided funds for infirm Episcopal clergy, and gave support to the Dunbar Colored Public School in Apalachicola. (AML.)

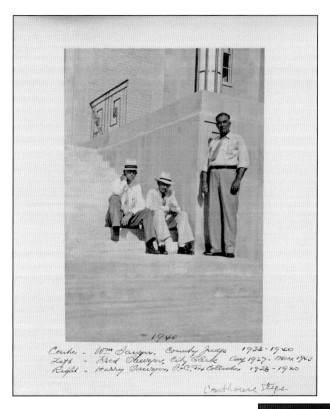

The Sawyer men were a family of elected officers; here they are on the steps of the courthouse in Apalachicola. Shown around 1940 are Fred Sawyer (left), city clerk from August 1927 to March 1943; Harry Sawyer (center), tax collector 1932–1940; and William Sawyer (standing), county judge 1932–1940. A very proud and noble group of men they were. (FS.)

Ruth Hall Schoelles graduated from Chapman High School in 1952 and was Harbor Day queen in 1952. She married Wayman Eldon Schoelles and has been in the realty business for many years. Ruth and Eldon bought the old Barefield/Convent schoolhouse in 1974 and moved it out to 11 Mile, where they live today with all their sons and families. (RHS.)

The Schoelles family included, from left to right, Phillip Schoelles; his mother, Mary Elizabeth Schoelles; and his sister, Alma Schoelles. This photograph was taken in the early 1920s. Phillip was a Franklin County commissioner and at times an entrepreneur. Alma married a man from out of state and moved away. (RHS.)

Thelma Schoelles, mother of Waymon Eldon Schoelles and wife of Phillip O. Schoelles, taught school in Apalachicola and was a very classy lady of her time. (RHS.)

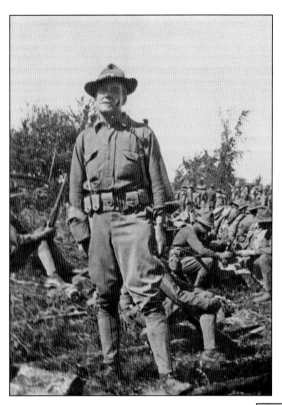

Stanley Sheip was the son of lumberman Jerome H. and Elizabeth Gwin Sheip. This photograph was taken of Stanley during World War I. Stanley was married in 1917 to Marie Layet Sheip, author of *Gulf Stream*. She died in 1937. (AML.)

Blicker Bartlene Sorensen was known as "B. B." to his friends. Lighthouse keeper at Cape San Blas Lighthouse during the war and bridge tender on the swing bridge into Apalachicola in the late 1940s and 1950s, Sorensen was known for his fishing, gardening, carpentry, and model-lighthouse building skills. His bridge tending career ended with injuries received when he was struck by a car on the bridge while leaving work. (DER.)

B. B. Sorensen is pictured with his youngest and oldest daughters, Louise Sorensen Evans (Silva) and Mary Sorensen Meadows. The Sorensen family lived on Thirteenth Street near Lafayette Park during the late 1940s and 1950s. They were active in the First Methodist Church and later the Wesleyan Methodist Church, which they helped organize, build, and support. (DER.)

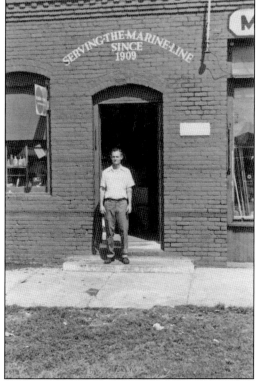

Louie Van Fleet was a longtime employee of Wefing's Marine Supply Store in Apalachicola. Louie started working for Wefing's about 1958 and worked there for over 39 years. Louie became very close friends with George and Elgin Wefing, and they even hunted together. Louie is now retired, Wefing's was sold, and Elgin and George have passed on, but memories are still there for Louie. (LVF.)

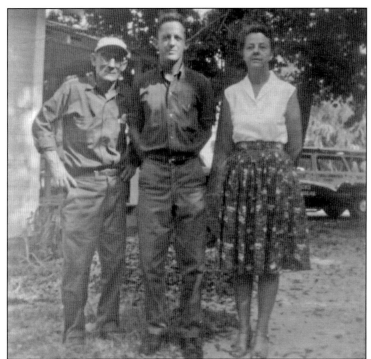

The Tarantino family arrived in Apalachicola in the late 1800s to be part of the growing seafood town. Pictured here from left to right are Sylvester; his son, Steven "Farris"; and Sylvester's wife, Thelma Tarantino. Sylvester's father bought his family here from Italy to make a better life for his family. Farris served as county commissioner for some time. (FPT.)

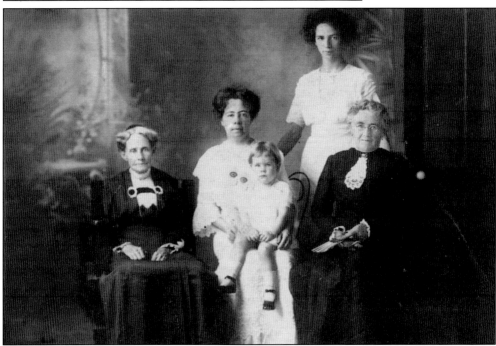

From left to right are Mary Isabelle Stewart Marks (wife of Charles Ferdinand Marks); her daughter, Estelle Marks Wefing, the wife of George F. Wefing; Elgin Wefing's wife, Agnes Wefing; their baby Merridy Wefing; and Elizabeth Elgin Wefing Hatch. Charles F. Marks was master of a vessel and ran the Union blockade to bring in supplies to the people of Apalachicola during the Civil War. (LG.)

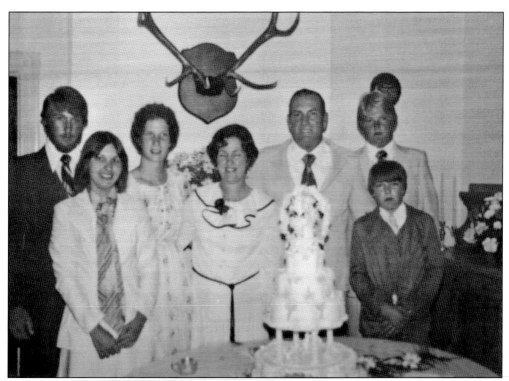

In this Ward family photograph, taken in September 1978 at Martha and Buddy's 25th wedding anniversary, family members are, from left to right, George, Dianne, Rachel, Martha, Buddy, Tommy, and the youngest, Joey. This family has been in the seafood business since the early 1930s. When Buddy took sick and passed on, the boys took over running the business. Tommy runs the oyster house out at 13 mile, and Dakie runs the shrimp house in town. (MMW.)

Buddy and Martha Ward were parents of five wonderful sons. Olan "Buddy" Ward devoted his life to the seafood industry. The family business thrived under his stern eye, with a growing fleet of shrimp boats, an oyster house, and a trucking company that would be respected around the country. Buddy met and married his partner in life, Martha Pearl Miller, in 1953. She has been a blessing to Buddy and her family. (MMW.)

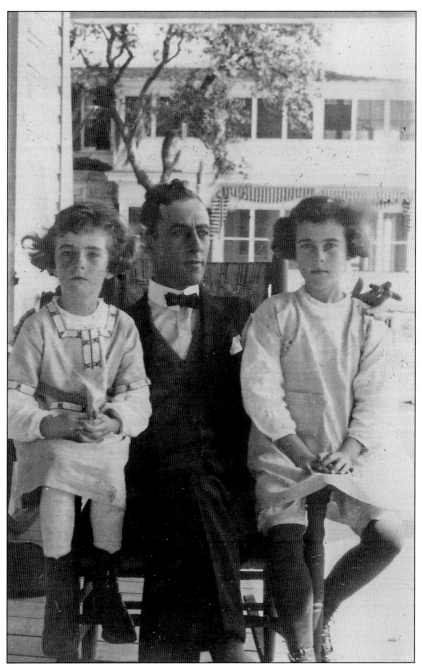

Dr. George Emerson Weems was reared in McDonough, Georgia. After graduating from public schools there, he received his medical training from Emory University. He graduated in 1904 and did his internship at Grady Hospital in Atlanta. He began his active practice in Newnan, Georgia. In 1909, Dr. Weems moved to Apalachicola, where he made his home. In 1913, Dr. Weems married Lillian Emma Wefing, and they had two daughters, Ruth and Marjorie. Dr. Weems considered his work a mission of first importance and was known as a friend as well as a physician. He was interested in his community and national affairs. He served on the local draft board during World War I. Dr. Weems died on November 26, 1956. (LG.)

Sam J. Johnson built many vessels in Apalachicola, including the *John W. Callahan* in 1907. In 1911, Sam was commissioned to build a new stern-wheeler, the *City of Eufaula*. In August 1912, he had the task of converting the *Crescent City* from a side-wheel to a twin-screw vessel. (AML.)

Captain and steamboat inspector George Henry Whiteside (seated) died just a few days before his 75th birthday in 1919 while on business for the Gorrie Ice Company. He was owner of the ice plant in Apalachicola. He was also instrumental in placing the monument in Gorrie Square. Capt. Samuel Judd Whiteside (standing) was master of the *Julia St. Clair* and carried the U.S. mail between Columbus, Georgia, and Apalachicola. (AML.)

Charles R. Witherspoon was manager of the Coca-Cola Company in 1916. In later years, he ran the Gulf Oil Distributor in Apalachicola and Carrabelle until his death in 1971. He was also senior vice president and director of the Apalachicola State Bank. His wife, Alatia Witherspoon, was an active member of the Methodist Woman's Society and Philaco Club. Alatia and C. R. were loved and respected by all. (AML.)

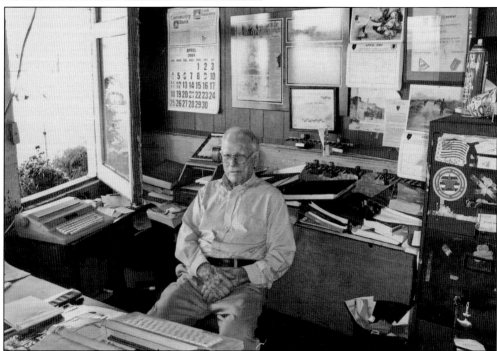

Genaro "Jiggs" Zingarelli is pictured at his desk inside the Franklin Press in 2004. Jiggs was one of the most well-known and beloved persons in Apalachicola. He died at the age of 93 in Port St. Joe, Florida. A decorated World War II veteran, Zingarelli established the Franklin Press in 1947 and printed a wide variety of documents using an antique Linotype machine and Kluge press. (DW.)

Two
Glimpses and Glibs of Old Apalachicola

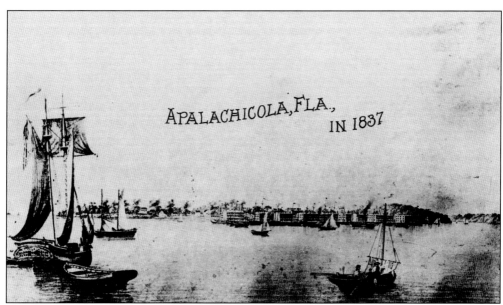

Apalachicola, Fla., in 1837, one of the most famous paintings of Apalachicola, was dreamed up by H. A. Norris, a civil engineer from New York who arrived here on January 10, 1836, to lay out the city. Accounts of 1838 told of 43 completed warehouses with three-story brick buildings lining the wharf area that ran for several blocks along the riverfront. A year later, the plans were accepted by the Apalachicola Land Company, and the basis of the present city of Apalachicola was formed. This view has been seen throughout the world. (AML.)

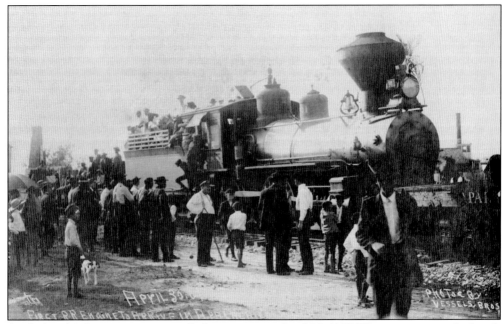

Apalachicola's first steam engine rolled into town on April 30, 1907. The event was marked with tumultuous celebration. The Apalachicola Northern Railroad, which entered town and ran parallel along what is now known as Water Street in downtown Apalachicola, connected 70 miles north to Gadsden, where it linked up with the east-west Florida lines and later to the Atlantic Coast Line. This photograph was taken locally by Vessel and Brothers in 1907. (FS.)

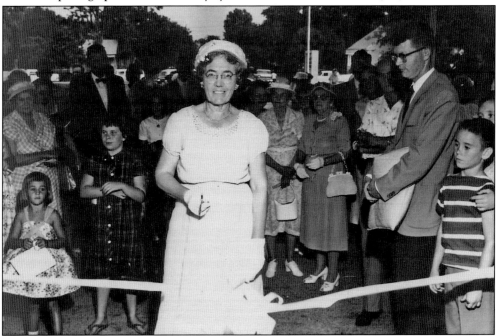

There was a ribbon cutting for the George E. Weems Memorial Hospital when it opened in 1959. Lillian Wefing Weems, widow of George Weems, is cutting the ribbon as others look on. Dr. Weems died in 1955. (LG.)

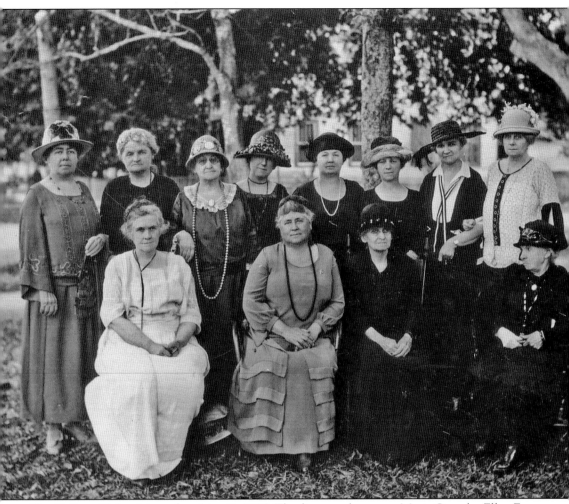

The Philaco Club originated on May 21, 1896. The first members were Maria Coombs, Ellen E. Pierce, Georgia E. Harris, Annie Marks, Mary A. Wise, Emily Rice, Sarah O. Griggs, Mattie Rush, and Estelle Wefing. At the second meeting on May 28, Sarah O. Griggs resigned and additional members were Fannie Ruge, Josephine LeFevre, Verna (Mrs. H. D.) Marks, and Mattie Patton. When the third meeting was held on June 4, new members were Mrs. George H. Ruge, Mrs. Paxson, Mary Peck, and Lottie Belle Marler, to make a total of 17 charter members. From left to right are (seated) Annie Willoughby Marks, Fannie Ruge, Emmie Whiteside, and Emily Rice; (standing) Estelle Wefing, Josephine LeFevre, Mattie Rush, Rosalie Wakefield, Etta Messina, Verna Marks, Mattie Patton (later Mrs. R. G. Porter), and Mattie Whiteside (later Mrs. Brunson). (AML.)

43

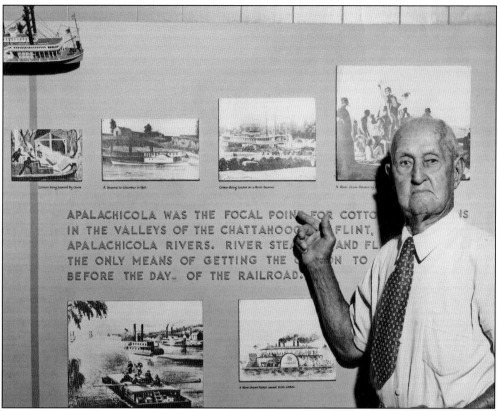

The oldest river pilot in Apalachicola was Capt. William "Bill" Fry. He came from a family of riverboat pilots. In May 1864, there were three Frys on the river; they were Daniel, Charles D., and Abe. William's father, Heber Fry, was one of the early pilots on the river. Fry died in mid-March 1894 in Apalachicola; he was one of the last links with the pioneer steamboat days of the late 1830s. (AML.)

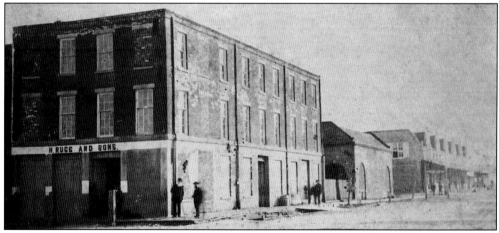

John Ruge and his brother George worked for their father in his machine shop and hardware store until they changed the name of the firm from Herman Ruge and Sons to the Ruge Brothers Canning Company in 1885. Taking advantage of pasteurization, they became Florida's first successful commercial packers, under the Alligator brand. (ABCC.)

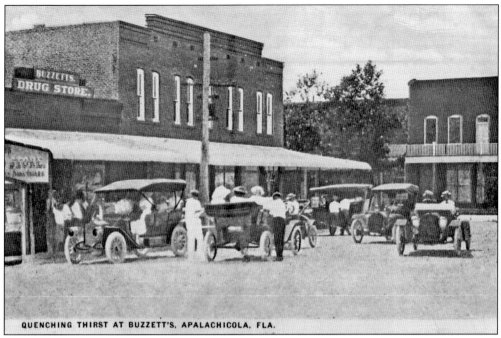

Buzzett's Drug Store, opened by William D. Buzzett in 1905, was later operated by his son John Joe Buzzett and became a landmark to local citizens for over 75 years. There was a soda fountain inside that was later moved up the street to the Old Time Soda Fountain, and is still open for business today. (RB.)

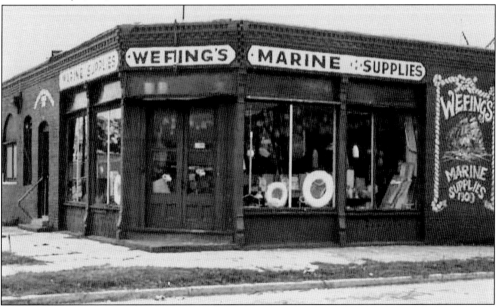

Wefing's Marine was founded by Elgin Wefing. Wefing's was originally a Ford Motor Company dealership. The Apalachicola area, no longer thriving as a farming community, had become a maritime shipping and seafood producing town, so Elgin quickly sold the inventory and ended his association with Ford. Wefing's Marine changed its offering to marine hardware and a precision machine shop serving the local fishing and shipping industries. (AML.)

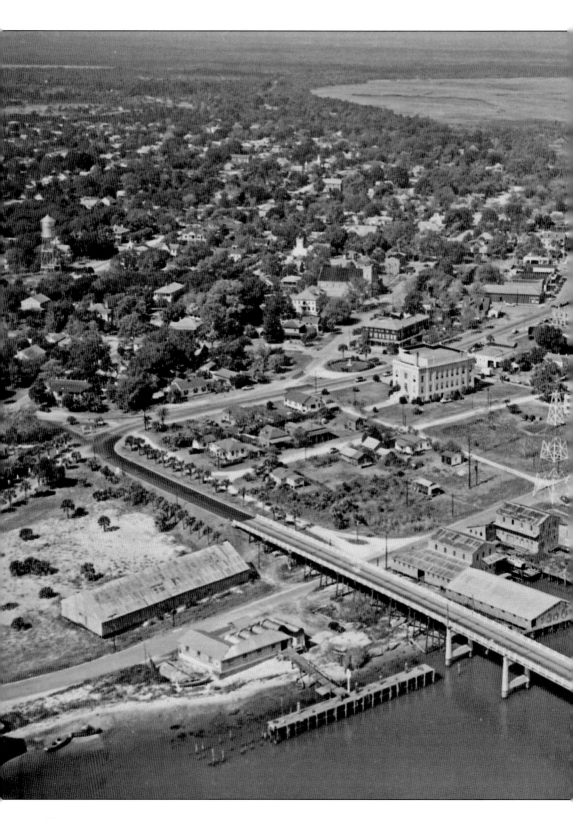

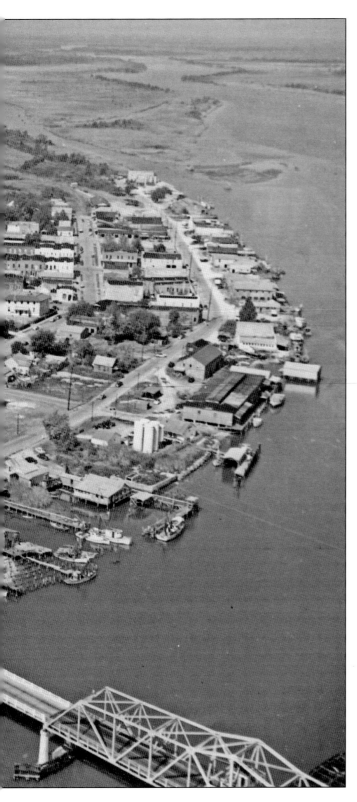

Apalachicola, Florida, located at the mouth of the Apalachicola River, is a city of homes, many with a cherished history. Some are more than 100 years old; others are remainders of slave time, champagne, wealthy owners, visiting dignitaries, and a Colonial atmosphere. Many of the fine old homes and buildings date from the 1830s. Most of the historic homes have been renovated, and new restaurants and shops have filled the vacant storefronts. A scenic walking tour of the town acquaints visitors with sites such as the old cotton warehouses, which housed the city's once-prosperous cotton export during the 1800s; a sponge exchange; and several Victorian homes still nestled among the old magnolia trees. Apalachicola has a proud history as an antebellum cotton-shipping port that was once the third largest city on the Gulf of Mexico. This photograph was taken about 1965. (AML.)

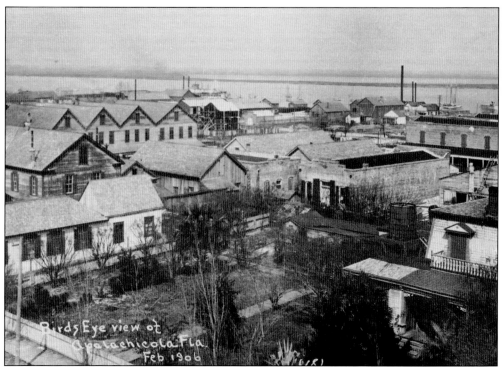

A bird's-eye view of the town of Apalachicola shows Avenue E and Market Street. At the right-hand corner is part of the Kimball House. At the corner of Chestnut Street and Market Street (top left) is a row of houses known as Brash Row, built in 1895 by Henry Brash. (FC.)

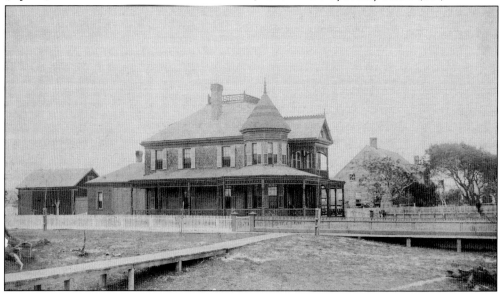

This home is a fine example of late Victorian architecture's Queen Anne style with romantic flair. The house was constructed of heart pine and black cypress in 1894 by August Mohr, superintendent of the Cypress Lumber Company. The builders were George and John Marshall. In the 1920s, the property was purchased by Anna Riscilli, who named the house Villa Rosa. In the 1930s, Villa Rosa became the home of Alexander and Margaret Key. (FC.)

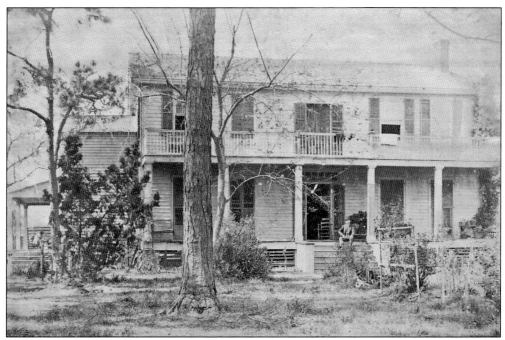

Porter House, original home of Richard G. Porter and his family, was built prior to the 1860s. Richard and his brother William were partners and were successfully engaged in the cotton business for over 30 years. (FC.)

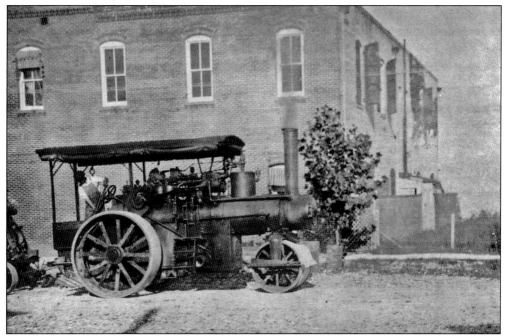

The beginning of the 20th century marked an era of progress for Apalachicola. By 1900, electricity was available, the lumber industry was constant, and the shellfish industry was booming. In this picture, a steamroller crushes oyster shell for a roadbed beside Montgomery's Dry Goods Store in downtown Apalachicola around 1900. (RHS.)

Sangaree Barber Shop was all about hair cutting at this historic landmark. It was started in 1914 by Veto (left) and Rhonat (right) Sangaree, both natives of Apalachicola. The going price then was 15¢ for a haircut and two shaves for 25¢. Regular customers had their own shaving mugs in the barbershop. Shortly after 1969, both brothers passed away within a few months of each other. (VSM.)

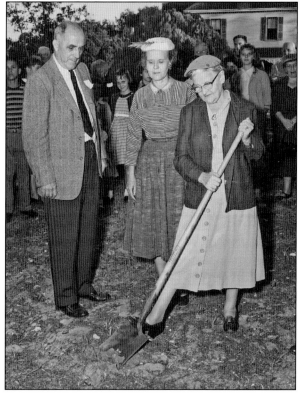

A state official and Rebecca Randolph look on as Mabel Osborne turns a spade of dirt for the new John Gorrie Museum. In 1956, Osborne donated this site for the state park. She said, "It is only fitting that we revive the memory and the works of this great man who contributed so much towards making America the healthiest nation in the world." (LG.)

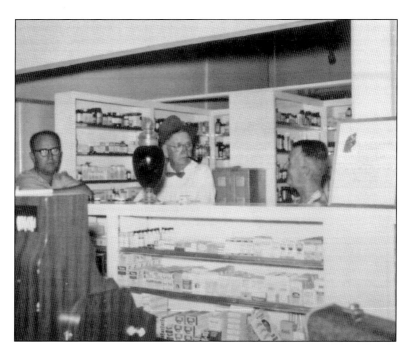

Hicks Drug Store was in business for many years; when starting out, the family lived upstairs over the store. In the years 1956–1960, according to Chapman High School yearbooks, the store had a lot of business. In this photograph are, from left to right, Dr. Photis Nichols, Dr. James A. Steely, and T. J. Hicks, owner of Hicks Drug Store in the 1940s. (PHP.)

Originally built in the late 1880s, this was the home of T. John Moore and his two sisters. One sister, Genie Moore, married a prominent lawyer from Miami, Robert F. Burdine, in February 1909, and the other sister, May Moore, married a Mr. Whiteside. May and her husband remained in the home and raised their family here. (AML.)

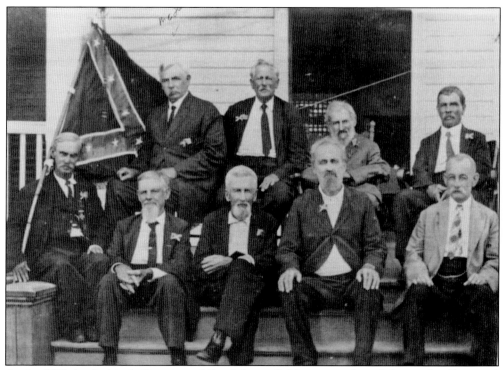

At the 1916 Apalachicola Reunion of Confederate Soldiers were, from left to right, (first row) William J. Donahoe, Amos R. Sharit, James Thompson Witherspoon, Stephen Ewing Rice, and Fredrick G. Wilhelm; (second row) Roderick Donald McLeod, Wilderman Francis Solomon, Antoine J. Murat, and William Peter Belleau. These were the "Old Veterans of the Grey," Franklin County's surviving Confederate soldiers. (AML.)

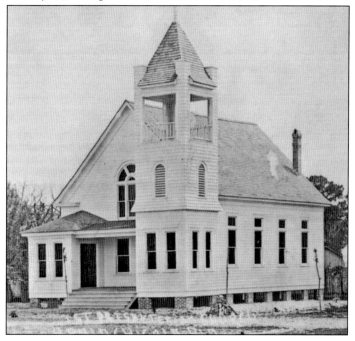

Apalachicola Presbyterian Church was organized in 1906 and built in 1910. Dave Maddox was the builder. J. D. Roundtree, the minister, did not pay the mortgage, and C. H. Lind foreclosed on the property in 1913. The building was sold in 1921 to the First Born Church of the Living God and moved to Eleventh Street between Avenues J and K. The building no longer exists. (MC.)

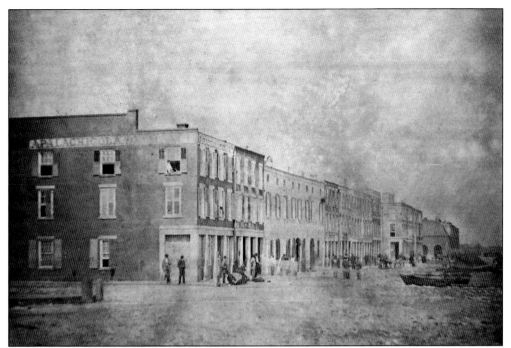

Shown here are rows of old cotton warehouses along Water Street, with the word "Apalachicola" on the end of the building in front. These buildings were all large three-story, fireproof, brick warehouses, and in the rear of the second floor were the counting rooms and adjoining sleeping rooms. Most of the clerks lived and worked in the same building, taking their meals at the nearby hotels. (ABCC.)

Woodson McMillan (here in 1938) was a well-known Apalachicola black man who made his living by farming, beginning in 1918. He planted 5 acres of his land and 11 for H. L. Oliver. McMillan had extraordinary success with vegetables and watermelons. The soil in this section of the Panhandle will grow almost any type of food. (AML.)

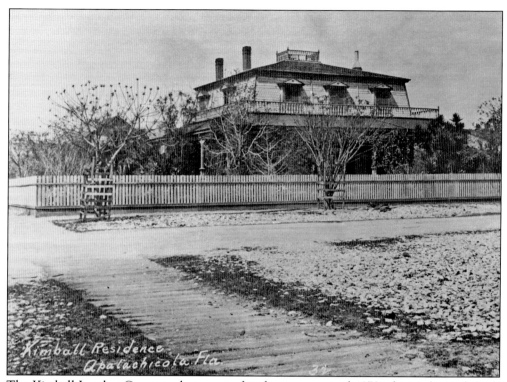

The Kimball Lumber Company lost most of its business around 1873 when it burned. Seth Kimball later went into business with J. N. Coombs. The Kimballs' daughter, Winifred Kimball, became a writer and published a book/song called "Broken Chains" around 1923. Their family home is believed to have been built on the very site of the first hostelry called the Mansion that was famous about 1850 in Apalachicola. (FC.)

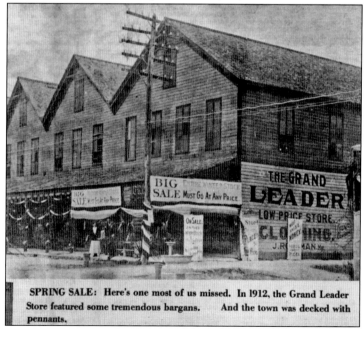

SPRING SALE: Here's one most of us missed. In 1912, the Grand Leader Store featured some tremendous bargans. And the town was decked with pennants.

This row of buildings was known as Brash Row, named for Henry Brash, who came to Apalachicola as a Jewish emigrant from Germany in 1865. Over a time, he owned and operated a dry goods, lumber, real estate, and sponge trade. He took over Harrison Mill but later sold it to the Cypress Lumber Company. (AML.)

This is the old boat lift/dry dock with 12 rails for vessels to rest on while inspections and hull repairs are done. The necessary boatbuilding and repair skills were there also, and lumber was nearby. Charley Ewing designed the dry dock (also known as "ship ways"), and it was operated by Ewing, Dwight Marshall Jr., and Anthony Taranto in 1973. It is gone today and replaced with a marina and Papa Joe Restaurant. (AML.)

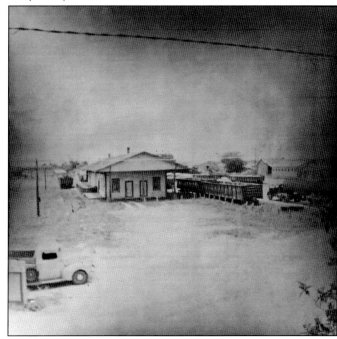

The Apalachicola Northern Railroad Depot and freight building was located at Commerce Street and Avenue G. This photograph was taken about 1955. C. T. Lanier was the depot master. Today it is no longer there. (AML.)

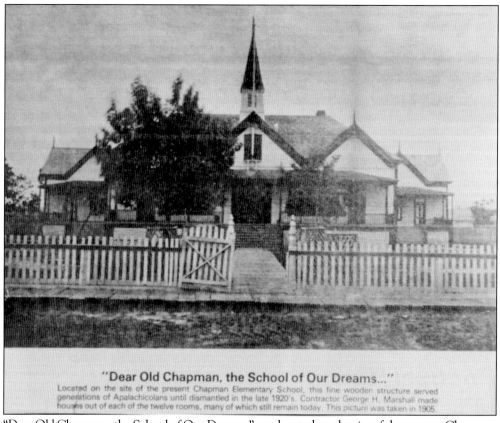

"Dear Old Chapman, the School of Our Dreams," was located on the site of the present Chapman Elementary School. This fine wooden structure served generations of Apalachicolans until dismantled in the late 1920s. Contractor George H. Marshall made houses out of each of the 12 rooms, many of which still remain today. This picture was taken in 1905. (ABCC.)

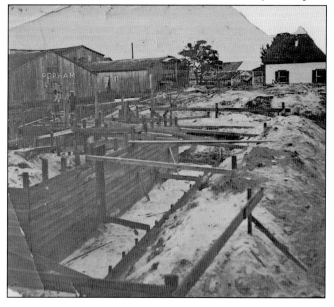

Popham Oyster Farms and Oyster Factory was owned by William Lee Popham, Apalachicola oyster entrepreneur. This famous oyster king was the first developer of St. George Island. The photograph was taken in the late 1920s during the construction of the rebuilding after the great fire of 1900. The Popham building was a two-story oyster-packing factory on the waterfront, and spelled out in oyster shells across the front was the statement "POPHAM OYSTER FACTORY NO. 1." (FC.)

J. E. Grady and Sons was a ship chandler, grocery store, and a warehouse (the two doors to the right). They sold ship's supplies for both river- and oceangoing ships. There is also (second door from the left) a bank along with another merchant store at the far left of the building. This building burned and was rebuilt. When it opened again in November 1900, it was renamed the Grady Building. (ABCC.)

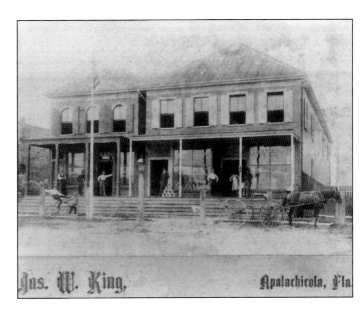

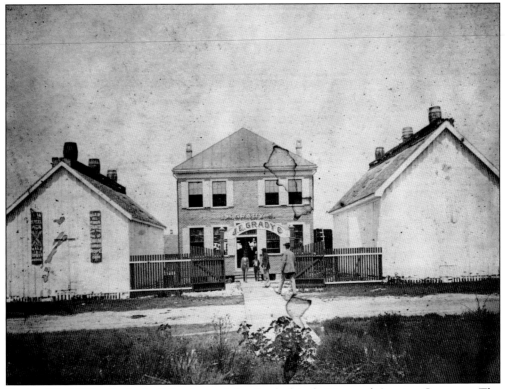

During World War II, the building housed the Apalachicola Tent and Awning Company. The second floor was named the consulate for the French official who lived there. It closed in 1933. The building was reopened as a tent factory during World War II and later as a net factory. Today the building is owned by Lee Willis and Lou Hill. (AML.)

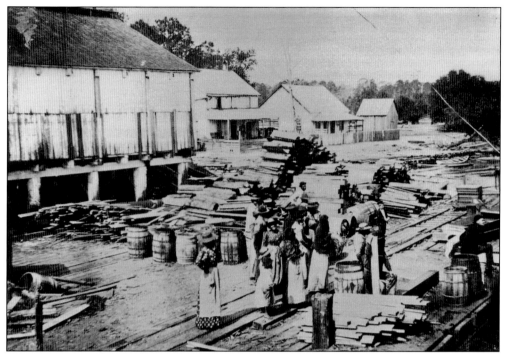

In 1894, the Coombs Lumber Company, located along Water Street in Apalachicola, was one of the several successful sawmills and lumbering operations in the county. In the 1890s, the demand for timber products was worldwide and the timber industry meant a large increase in traffic on the Apalachicola River. In 1898, more than $13 million of mostly timber products were shipped via the Apalachicola River. (AML.)

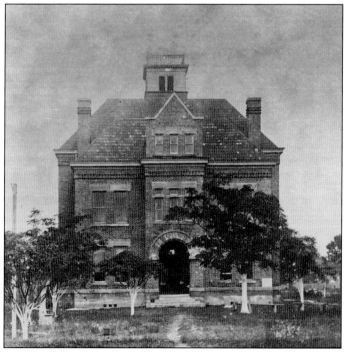

Franklin County Courthouse was built in 1892 and located in Apalachicola at the site of the present-day hospital. Torn down in 1957, this venerable brick building was actually the county's second courthouse; the first was built on the city's waterfront but was destroyed by fire in 1874. This *c.* 1916 building was a 40-room Curtis House, and it served as a full-time hotel and a part-time theater. (LZ.)

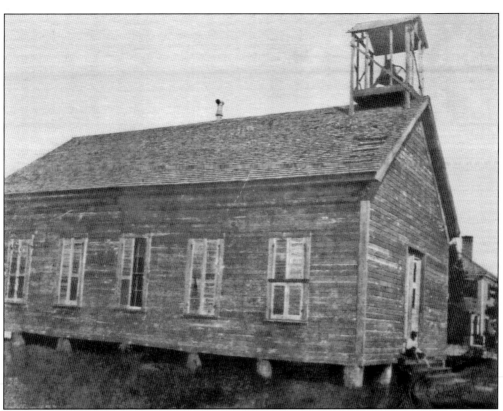

The First Baptist Church was constructed in 1848. The church was originally located at the corner of Avenue H and Sixth Street across the street from the Montgomery house. In 1902, the church was rebuilt in its present location on Ninth Street and renamed Calvary Baptist Church. In 1934, church members decided to change the name back to First Baptist Church. (LH.)

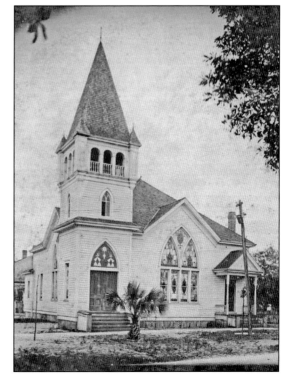

Calvary Baptist Church was originally known as the First Baptist Church and sat at Avenue H and Sixth Street. Now here it is in 1920 with its new name and a new location, 46 9th Street. The first pastor here was Rev. T. D. Reese. After 1934, the church name changed back to First Baptist Church, which it remains today. In 1984, the First Baptist Christian School was established. (HL.)

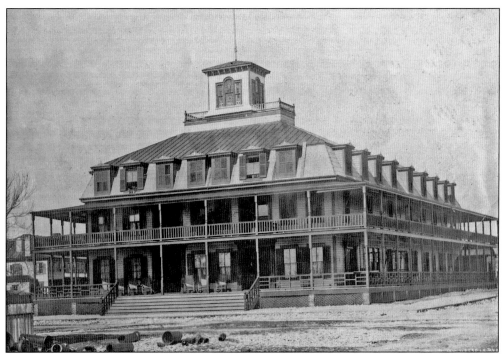

The Franklin Hotel was built in 1907 by South Carolinian James Fulton Buck from handpicked cypress on land that he owned. When the hotel opened, it charged $1.25 per night for a room. In the next decade and a half, the hotel went through some bad times as the tastes of tourists changed and visitors bypassed Apalachicola. In 1923, the Gibson sisters bought the building and changed the name to the Gibson. (LZ.)

The Hut, one of Apalachicola's best seafood restaurants, has been serving diners since 1941. Owned and operated by Lucille Silva Saker and her family since the 1980s, this great restaurant was enjoyed by many, from locals to those from far away. It was destroyed in 2005 by Hurricane Dennis and reopened in Eastpoint, Florida. (LSS.)

George Washington Saxon got interested in Apalachicola at the end of the 19th century. In Tallahassee, he started in the 1880s a store including a private bank under the name of G. W. Saxon and Company. His firm became an outstanding facility that was incorporated under the name of Capital City Bank in 1895. A branch of this bank was established in Apalachicola in 1897 and ran until 1906. (AML.)

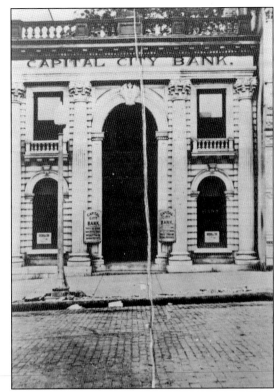

Apalachicola Chamber of Commerce's 1954 members were, from left to right, (seated) Pres. A. V. Beson and Sec. Teresa Holloway; (standing) directors C. R. Witherspoon, Jack Cook, Eldon McLeod, Mannie Brash, Dwight Marshall Sr., John J. Buzzett, C. M. Henriken, L. G. Buck, J. G. Bruce, Billy Buzzett, and W. F. Randolph. (AML, Jimmie J. Nichols Collection.)

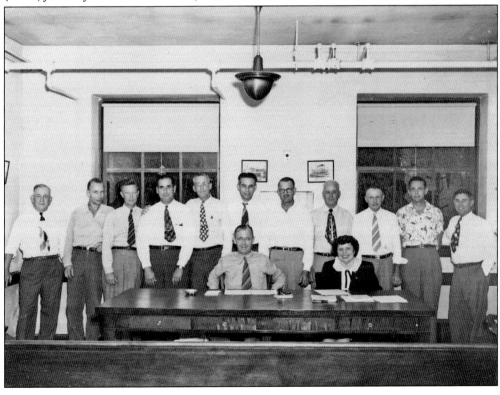

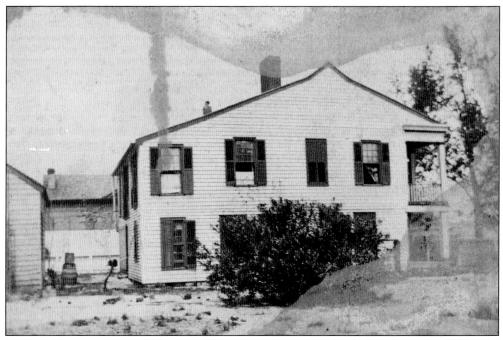

Herman Ruge, a native of Hanover, Germany, migrated to Apalachicola in the 1880s and established a hardware store, blacksmith, and machine shop. His sons, John and George, worked with him, and in 1885, the family business became Ruge Brothers Canning. This house was their home until the sons married. (AML.)

George H. Whiteside was the owner of the Apalachicola Ice Company, a local ice plant just off the waterfront. He was also a member of the Southern Ice Exchange. This photograph was taken just after an explosion happened in 1886. (AML.)

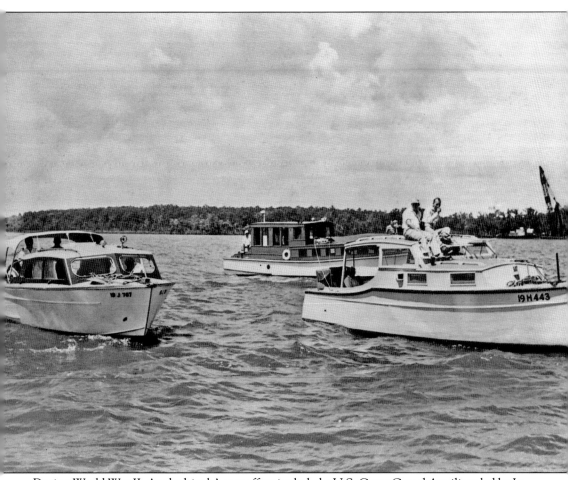

During World War II, Apalachicola's war effort included a U.S. Coast Guard Auxiliary led by Lt. Elgin Wefing. This unit, consisting of local commercial and pleasure boats, patrolled the waterways of the immediate area of the Apalachicola River and Bay, the Gulf of Mexico, and adjacent waters. In this photograph are several of the locals who were involved with patrolling the Gulf: the *Southwind* and owner Mannie Brash; the *Sea Dream* and owner W. Randolph; and the *Miss Josie* and its owner, Bob Nedley. On the cabin to the right is Jack Cook with an unidentified man. In 1942, the *Sea Dream* rescued 14 British sailors when the *Empire Mica* was sunk off Apalachicola by German Sub V67. The *Sea Dream* had run out of gas and had to be towed in with its crews and survivors to Apalachicola. This was Apalachicola's first wartime emergency. (AML.)

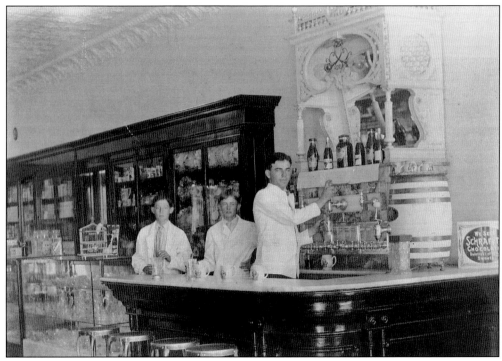

Here is a photograph of an old-fashioned drugstore soda fountain. It was taken around 1910 inside of the long-ago Buzzett's Drug Store. Standing here are Gene Austin (left) and two unidentified young men. (RB.)

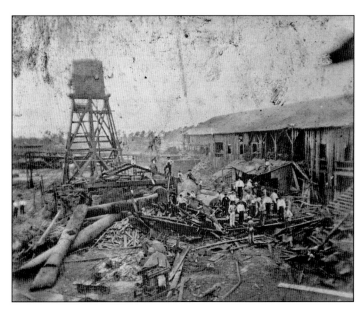

In the early 1900s, there were many fires in Apalachicola: in 1853, 1873, 1874, and the one everyone remembers, the fire of 1900. Businesses lost were lumber, warehouses, and cotton stores. The loss most of the time was covered by insurance but not always completely. In October 1890, Kimball Lumber Company lost 4 million feet of lumber, and in October 1915, Cypress Lumber Company burned, entailing a loss of $3,000. (AML.)

Three
JUST FOR FUN

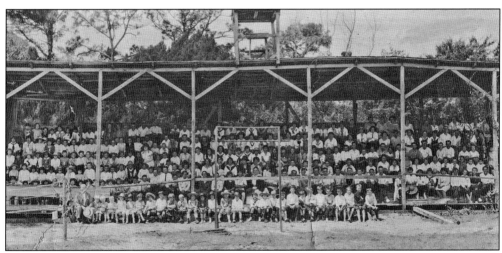

At Porter Field, in 1910, was this grandstand that could seat 300 people during a baseball game. The entire front was wired as well as the bleachers to protect those occupying seats here. The scorer's stand was placed at the top of the grandstand, where he could have an uninterrupted view of the game. The baseball field's entrance was opposite R. H. Porter's residence, while entrance to the bleachers was next to T. F. Porter's residence. All in all, the grounds are decidedly the best ever had in Apalachicola, and J. A. Power deserves the thanks of lovers of the game for the work he did to secure the improvements. Many of the Porter boys were great baseball players: Ned, Richard, and Dick Porter, along with Jimmy Bloodworth (1937–1951), who went on to play professionally. (FC.)

Here in 1965, this is a fisherman's heaven located in the Panhandle of Florida. It offers some of the finest freshwater fishing and lodging in wooded and tranquil surroundings. It was owned by Jimmy Mosconis and dates back as early as 1932. The Bay City Lodge offers the best inland saltwater and freshwater fishing found along the Apalachicola River. (AML.)

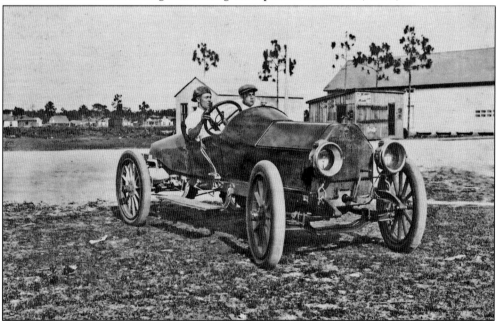

Herman McNeil (left) and Harry Sawyer (right) have been enjoying an outing autoing in their 1913 Stutz Bear Cat through the country and have extended their route as far as Jackson County, returning back to Apalachicola from weeks of journeying as Rough Riders. (FS.)

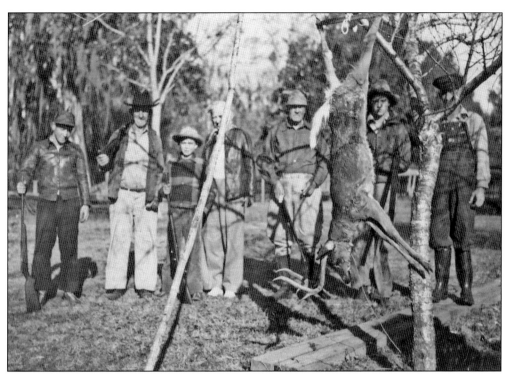

This little hunting party was pictured in 1945 in the Brickyard area, near Harry Avery's bee yard. From left to right are Red Anthony, unidentified, Freddie Buck Sawyer, Inez Sawyer, Harry Sawyer, the deer, unidentified (maybe Admiral Brown's boy), and Paul Stansbury. (FS.)

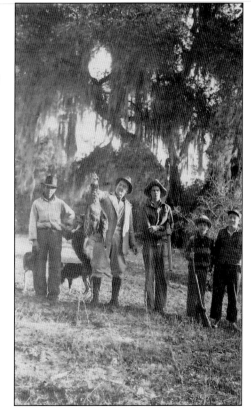

The Sawyer hunting party is seen here during turkey season in 1945. The group was hunting up around Brickyard Landing. From left to right are Dewey Brown, Harry Sawyer holding up a dead turkey, Adm. D. Brown, Freddy B. Sawyer, and Red Anthony. (FS.)

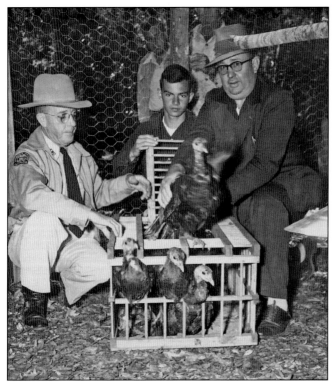

These young wild turkeys were being released at Box R. Ranch around 1950. From left to right are an unidentified game warden, high schooler Fred B. Sawyer, and Floyd Nixon, northwest regional manager of the Game and Freshwater Center. (FS.)

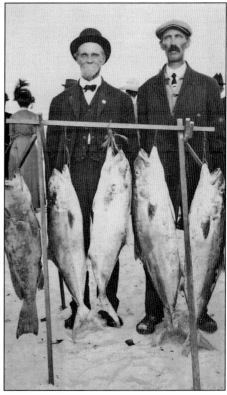

Benjamin Sharit and his uncle Ben Sharit are standing here with a fresh mess of amberjack and grouper they caught in the late 1920s. (FS.)

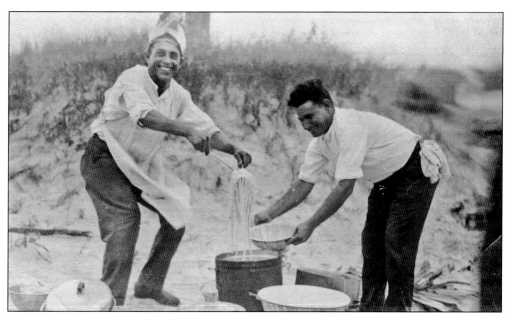
Joe Taranto (right) and Salvadore Castorina (left), a couple of local Italians, enjoy an outing on the beach by cooking spaghetti about 1926. (DTR.)

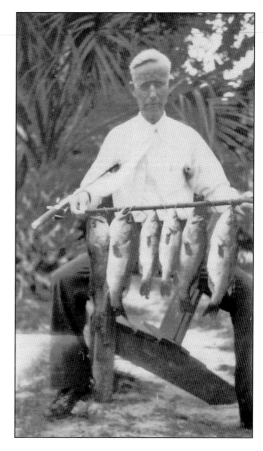
Fred Sawyer Sr. shows off his catch of bass, caught at Turtle Harbor Pond, up near the old Cypress Lumber Company, around 1935. (FS.)

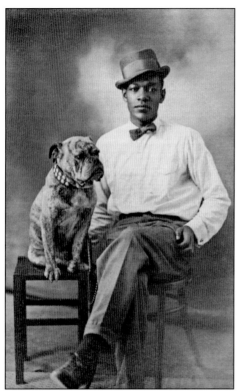

Here is a photograph of a handsomely dressed gentleman with his dog—a most unusual portrait and unquestionably curious item. Not many African Americans had their photographs taken in the South during these times, but the author wanted to add this proud and majestic photograph to honor the men now descended who could not be included at this time, such as Spartan Jenkins, Emmanuel Smith, and Edward Tolliver. (RHS.)

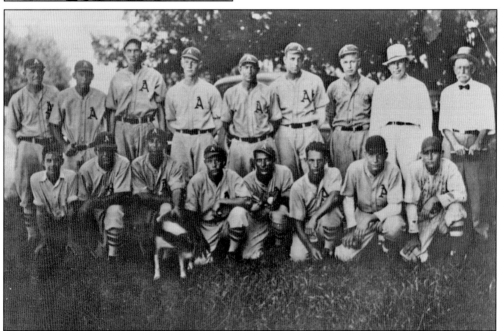

Apalachicola's 1932 baseball team included, from left to right, (first row) George Core, George Suber, Willie F. Randolph, Carl Morton, B. Frances Bloodworth, Ivan Truman, Ed Hires, and Rex Buzzett; (second row) Ned Porter, Richard Porter, Fred Richards, Joe Hiles, Bill Owens, J. J. "Buddy" Teague, George Hiles, J. Johnston, and Dick Porter. (AML.)

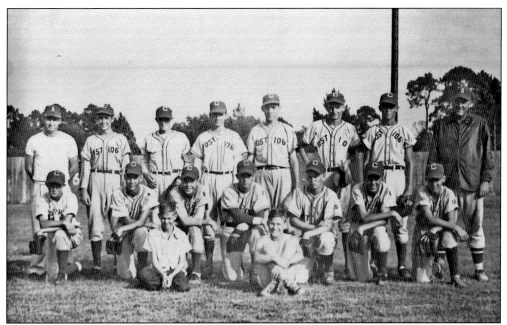

Baseball Post No. 106 is pictured here. From left to right are (first row) two unidentified boys; (second row) Dickie Bloodworth, Joe Warden, unidentified, Charles Smith, Ronnie Bloodworth, Tommy Patton, and Fred Matthews; (third row) coach Bill Wagner, George Martina, Red Davis, Fred B. Sawyer, ? Bohannon, Jackie McNeil, unidentified, and coach Joe Pope. (FS.)

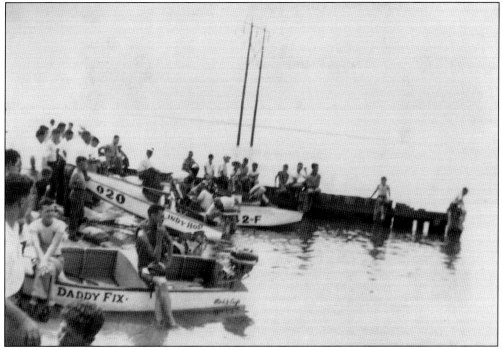

Eldon Schoelles, in his younger days, would dare his friends to see who could get up the Apalachicola River to Columbus, Georgia, before the other. Schoelles, driving *Daddy Fix*, was the winner. The Fourth of July boat races were always a popular event in Apalachicola. (RHS.)

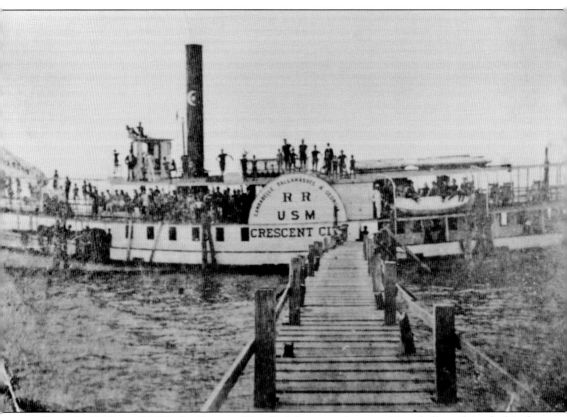

From the 1890s until 1923, the *Crescent City* plied the waters between Carrabelle and Apalachicola as a mail and passenger steamer and to St. George Island as an excursion ferry. The lower deck was used for freight and deck passengers and the upper deck for first-class passengers with a comfortable cabin provided for their use. She was captained by Apalachicola's own Andy Wing. This was about 1912. (RHS.)

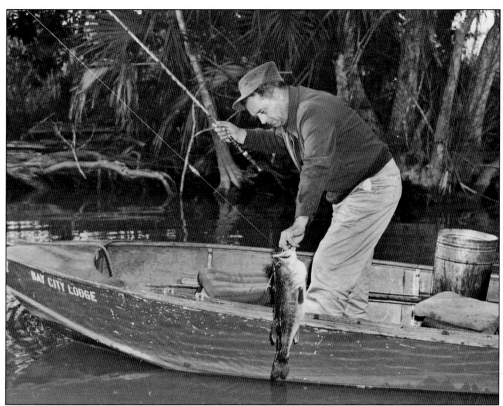

James Waddell Sr. always enjoyed a little fishing up around the Bay City Lodge on the Apalachicola River. Here he is in 1956 showing how much fun freshwater fishing can be. (AML.)

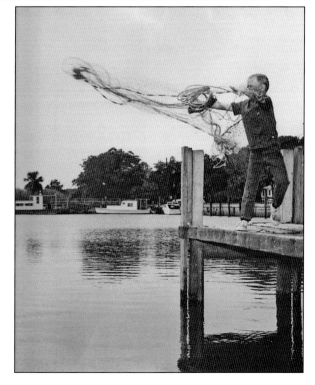

Ninety percent of the youth in Franklin County know how to throw a cast net by the age of 10. Here young Richie Watts at age seven throws a circular cast net off the dock. It is also a fun way of keeping entertained and catching a nice mess of mullet. (AML.)

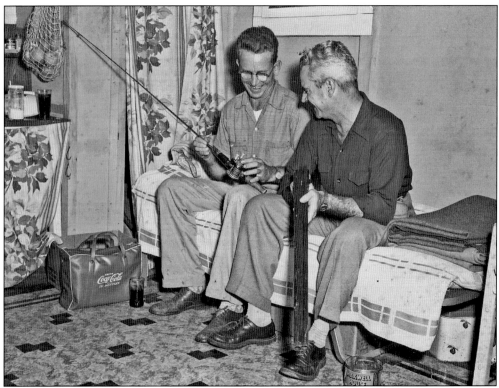

Roy Smith is showing something about his fishing pole to James Mahon (the man on the right with shotgun) during a hunting trip up the Apalachicola River in the 1960s. The houseboat belonged to Mahon and Joe Zingarelli. Smith was famous for his Witch Craft sport boat, which was locally manufactured in the 1950s, and he invented the oyster-shucking machine that is still used today. (BMB.)

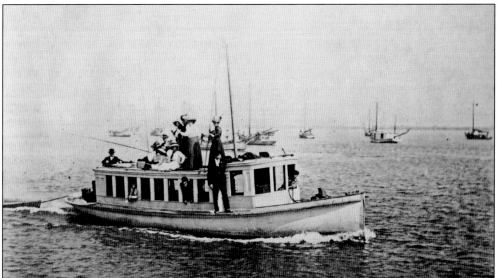

The *James M. Coombs* was owned by George Marshall of Apalachicola. It ran from Apalachicola to Pensacola, Florida. (AML.)

Four
Festivals and Celebrations

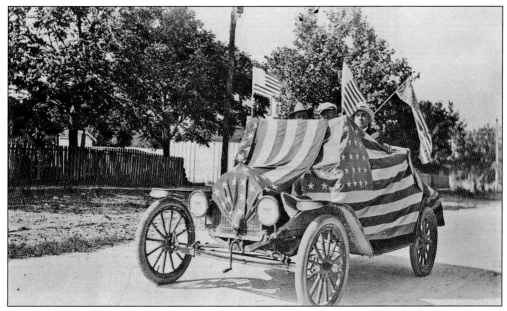

Pictured here is the 1916 Mardi Gras parade with Harry Sawyer driving this colorful car decorated with the American flag. The other two gentlemen are unidentified. (FS.)

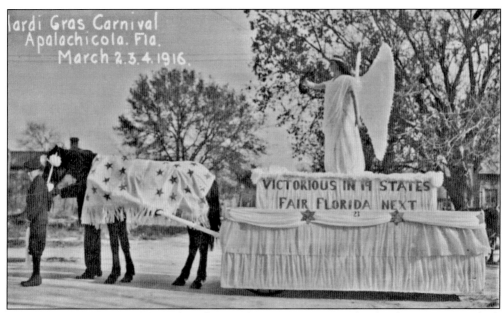

A life-size figure of an angel dressed in white, with wings to correspond and with arms outstretched, holds a green wreath in her hands. On the pedestal were the words, "Victorious in 19 States. Fair Florida Next." Designed by William Sawyer and entered by the local Women's Christian Temperance Union society, this float was one of three prizewinners in the March 1916 parade. (AML.)

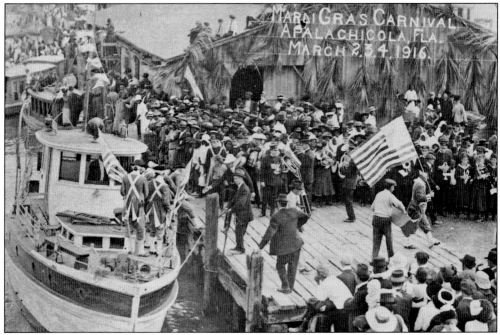

Mardi Gras Festival is a big success. The mayor delivers the keys to King Retsyo I and Queen Miriam. During this celebration from February 11 to 13, 1915, the arrival of the king was on the steamer *City of Columbus*, joined by the queen and her maids; they marched through the streets with bands of music. At the Carnival Ball were the unmasking of the king, John H. Cook, and the crowning of the queen, Miriam Marks. (FC.)

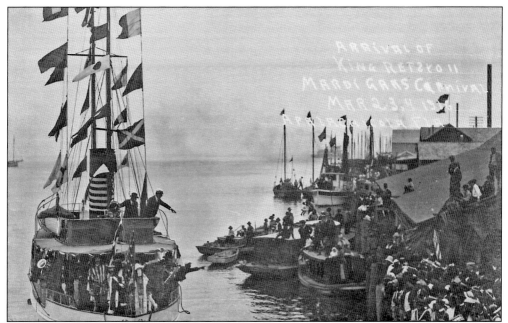

King Retsyo II (Karl Mohr), accompanied by his courtiers, landed from the good ship *Roamer* at the Tarpon dock in the presence of a mass of people estimated at 5,000. Preceding the *Roamer* was a large number of boats gaily decorated with bunting. When opposite the dock and just before making the turn, the *Roamer*'s guns fired a king's salute. Mill and boat whistles joined in the noisy welcome. (FS.)

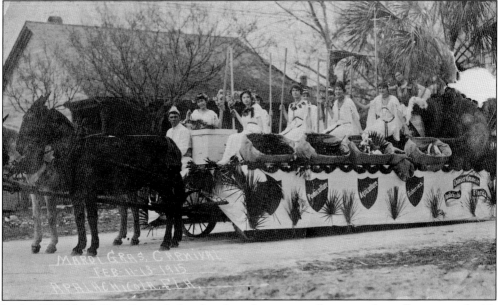

In the 1915 Mardi Gras Festival, the chamber of commerce float was a large float covered with green and bright-hued flowers. The nine pretty young ladies who occupied this float were, from left to right, Caddene Montgomery, Elia Barmore, Martha Stovall, Edith Montgomery, Juddie Bishop, Mary Solomon, Olive Floyd, Eva Terry, and Hortense Cummings. The driver is unidentified. (AML.)

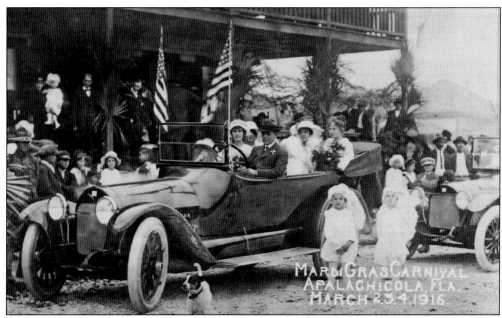

Queen Genivieve Pierce (at right in the backseat with an armful of flowers), who was crowned by King Retsyo as the 1916 Mardi Gras queen, is being driven by Homer Oliver along with her maid of honor, Dorothy Sawyer. The lady in the backseat (left) is unidentified; she is assumed to be the queen's mother or last year's queen. The car is a 1915 Buick, model C-55, seven-passenger touring car. (FS.)

The 1916 Mardi Gras was held at the armory. The "Junior" queen and king were Dorothy Wefing, elected "Queen of Beauty," attended by her royal consort, Edward Hays (age 9). They are attired in the costumes of the reign of Louis XVI, and their quaint beauty was much admired. (PHP.)

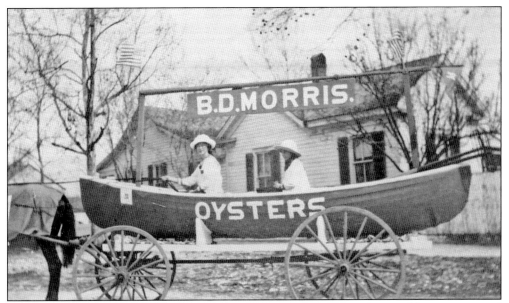

Two young ladies setting off for the Mardi Gras parade in an oyster boat in blue are equipped with oyster tongs. Florence Morris (left, lady-in-waiting to the queen) and Lamar Hickey (right) constituted the "crew." Above the boat is the sign of the owner, Byron D. Morris. The photograph was taken in front of the old Hawkins home, now the Morris family home. (WC.)

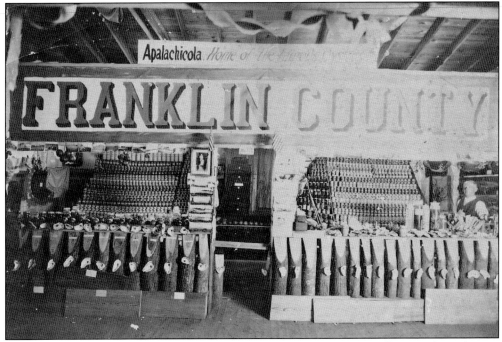

In the Franklin County booth, there are a variety of exhibits planned to illustrate the industries of the county. Here during the 1916 Mardi Gras Festival is a special attraction posting Messina's "Pearl Brand" oysters, shrimp, fish, and roe. Check out the oranges and local photographs hanging around the booth. Look at all the oyster shells they have displayed and the native woods and lumber out front. (FC.)

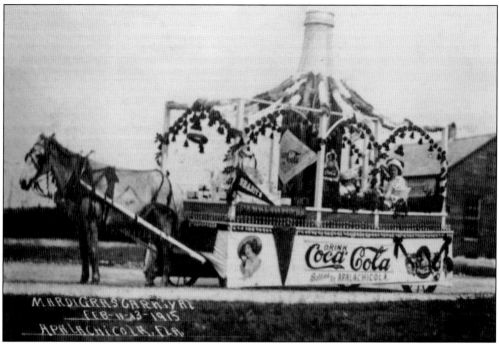

The colors of the Bay City Bottling Works float were green and yellow. In the center was a 10-foot bottle of Coca-Cola, with many green and yellow ribbons extending from the bottle to the four corners of the float. In the rear, there was a garden depicting all the freshness and coloring of spring. At the rear of the float were seated, from left to right, Whitaker Pooser, Edward Meyerhoff, Lucille Messina, and Idell Murphy drinking Coca-Cola. (AML.)

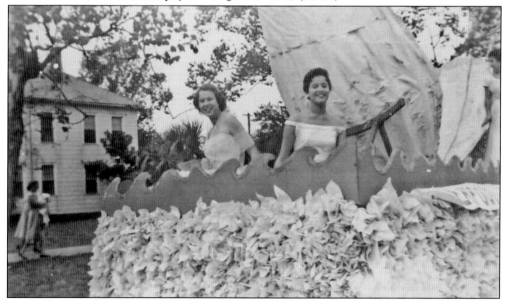

On Harbor Day one November in the 1950s, Patsy Hays (left) and Penny Hicks (right) ride on the Homecoming float from Chapman High School in the Harbor Day Parade. Patsy was Homecoming queen in 1956, and Penny was one of the Homecoming attendants in 1956, queen in 1958, and annual queen in 1959. (PHP.)

The Blessing of the Fleet is a solemn ceremony that originated in the Old World and was performed to protect from dangers of the deep the men who go down to the sea in ships. The priest goes to the waterfront, blesses the boats, and calls on God to protect the men and their boats and reward them with successful catches. A Greek priest, a Catholic priest, and an Episcopal priest would participate in the Blessing of the Fleet. From left to right are J. J. Nichols, Greek Orthodox priest James J. Laliberte, John Zingarelli, Catholic priest John Bender, J. N. Nichols, Jean Chance Jr., and Episcopal priest Jean Chance Sr. (AML.)

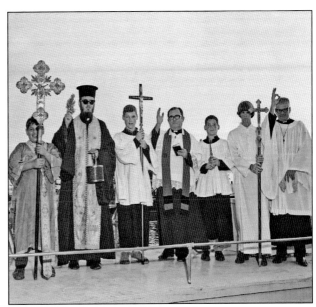

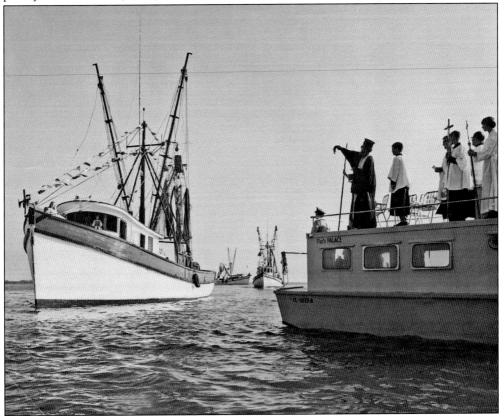

Performing the 1969 ecumenical blessing of the seafood fleet during the Blessing of the Fleet ceremonies are, from left to right, acolyte John J. Nichols, Greek Orthodox priest James J. Laliberte, John Zingarelli, acolyte John N. Nichols, Episcopal priest Jean Chance, Catholic priest John Bender, and acolyte Jean Chance Jr. on the boat in the middle of the river. (AML.)

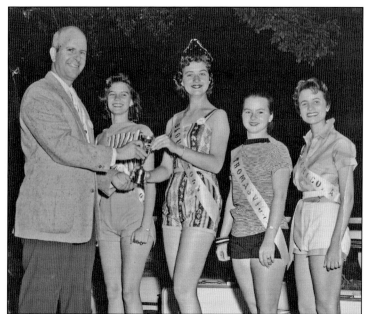

The queen of the Apalachicola Rivercade is accepting her trophy and set of luggage in 1957 during the Harbor Day. From left to right are Jimmy Nichols, mayor of Apalachicola; Alice Ruffin, Miss Bainbridge, Georgia; Queen Elizabeth Peacock, representing Blountstown, Florida; Patty Bellamy, Miss Thomasville, Georgia; and Penny Hicks, Miss Apalachicola, Florida. (AML.)

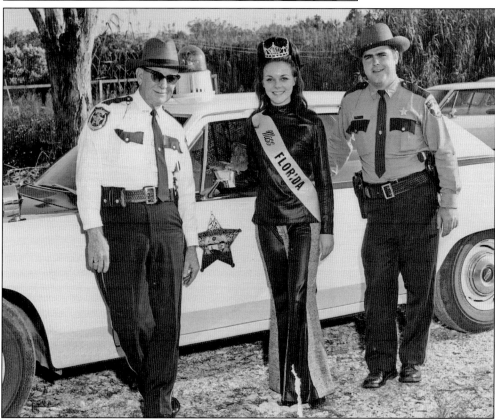

Shown here are, from left to right, Apalachicola's finest city policeman, Boyd Howze; Miss Florida Lynn Edea Topping, from Dade County, Florida; and Franklin County sheriff Joel Norred. They are posed in front of the sheriff's car at the 1969 seafood festival in Apalachicola. (AML.)

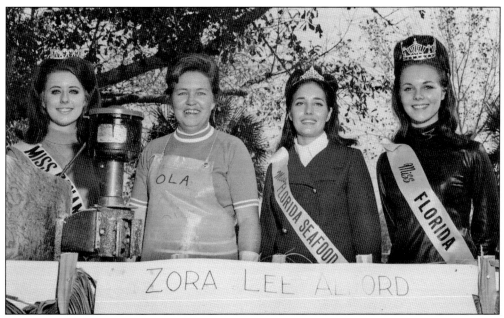

Zora Lee Alford was the Florida Seafood Festival's oyster-shucking champion. Recorded this year (1969) were 50 oysters in 2 minutes and 48 seconds. From left to right are Miss Panama City's queen, Dianne Bass; Zora Lee Alford; Miss Florida Seafood Mary Helen Marshall; and Miss Florida Lynne Edea Topping. (AML.)

Apalachicola's 1968 oyster-shucking champion, Helen Hicks, can shuck 50 oysters in three minutes using no machine, hands only. (AML.)

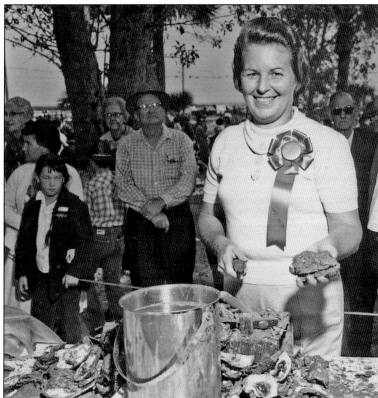

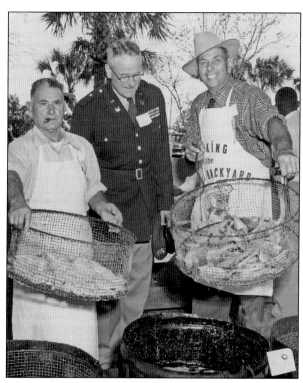

From left to right, Joe Taranto, an unidentified officer, and Sheriff Herbert Marshall show off their mullet-frying skills. (AML.)

At the 1970 Florida Seafood Festival were, from left to right, (seated) Seafood Queen Valeria Rolstad and Chief Joe Taranto; (standing) Congressman Don Fuqua, Mayor James Daly, Jimmy Nichols, and harbormaster Tom Cook. (DTR.)

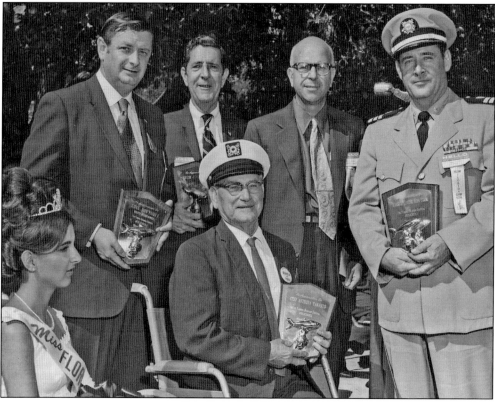

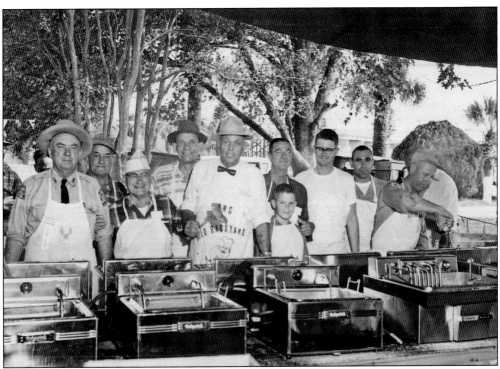

At this Harbor Day celebration in 1955 is a group of men getting ready to start frying mullet. From left to right are Ollie Montgomery Sr., Guy Messina, Joe Taranto, Luke Moren, Herbert Marshall (with mullet), Bobby Howell III, Roland Schoelles, Bobby Howell Jr., Anthony Taranto, and unidentified. (AML.)

Young Edward Philyaw, at the age of five, advertises "how to eat an oyster." (AML.)

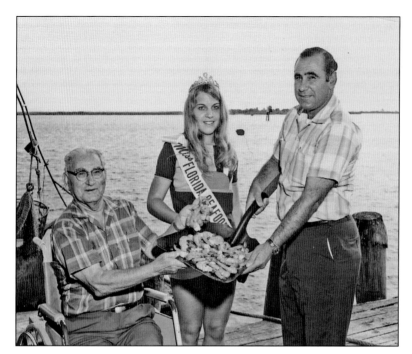

Capt. Joe Taranto (seated); the 1971 Miss Florida Seafood Queen, Lisa Barber Carroll; and Anthony Taranto, with a shovel of jumbo shrimp, were photographed during the seafood festival. (AML.)

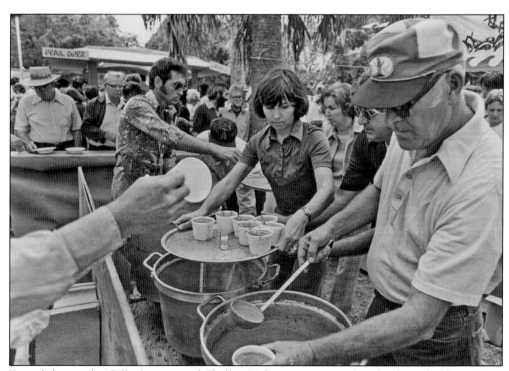

From left to right, Billy Switzer and Phyllis Wefing pour cups of seafood gumbo for waiting customers, along with Buddy Hoffman, at the 1969 Apalachicola Seafood Festival, later to become the Florida Seafood Festival. (AML.)

Miss Florida Seafood Festival Elizabeth Zingarelli believes pearls are unnecessary when one has oysters like the Apalachicola Bay produces. Those who came to the Florida Seafood Festival on Saturday, November 3, 1973, had the opportunity to enjoy the finest seafood ever—and lot of good entertainment, too. (AML.)

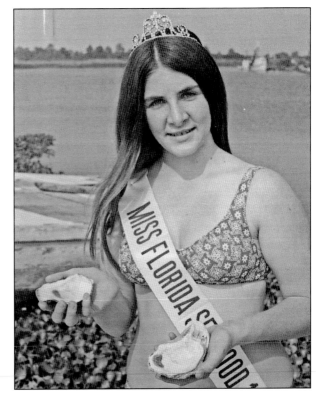

Chapman High School's eighth-grade Homecoming queens, pictured in November 1971, were Tammy Marshall (left) and Jerri Ann Rish. The girls were driven in Margaret Key's car. (AML.)

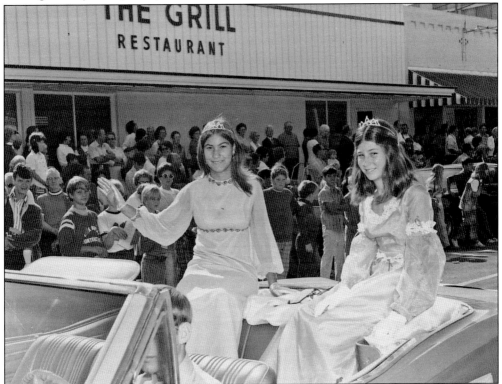

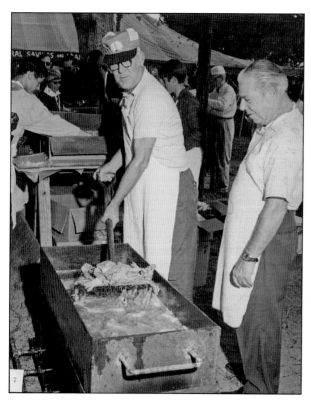

The man frying fish here is Buddy Hoffman, shoveling mullet, with Mac McCormick looking on. This photograph was taken during one of the seafood festivals. (AML.)

From left to right, Congressman Don Faqua and his family, state senator George Tapper and his wife, and Mayor James Daly (across the table) enjoy their fish dinners served at the seafood festival in 1970. (AML.)

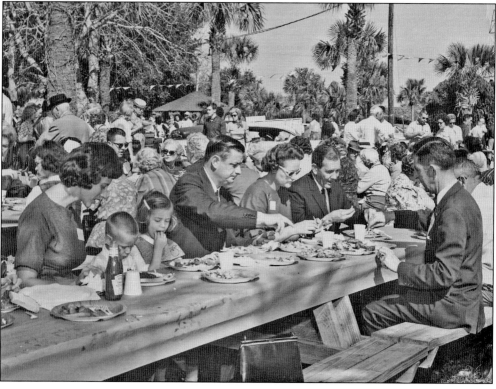

Five

SCHOOL OF OUR DREAMS

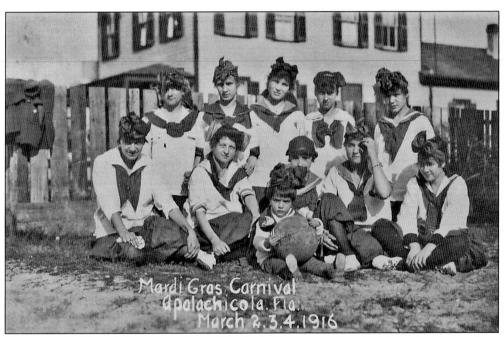

During the 1916 Mardi Gras Festival, a girls' basketball game was played with Apalachicola taking on Leon High School. According to the *Apalachicola Times*, "Leon High School Wins from Chapman High 16 to 3." Manager Francis Wakefield of the home team met the party of girls from Leon High, and they were taken to the home of Emma Patton to get ready for a fish dinner given at the Olympia for them by the city editor of the *Beacon*. George Palazzo did himself proud in his entertainment. The photograph here was taken during this event of the home team. Though the girls are unidentified, the home team players were Fay Hose (captain), Lottie Witherspoon (forward), Emma Roan (center), Clyde Brown (center), Alma Wing (guard), Vivian Maddox (guard), and Jeanette Theobald (guard). (FS.)

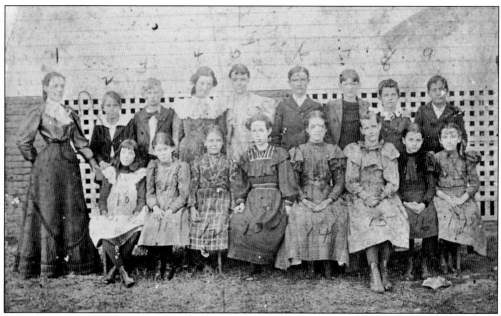

This 1880s elementary school class, taught by Stephie Rice, included, from left to right, (first row) Alice Parlin, Mollie ?, Carrie Floyd, unidentified, Mattie Hill, B. Johnson, Ethel Pickett, and Mabel Pierce; (second row) Bruno Nightengale, Charlie Blocker, Emily Castorina, Willis Crowson, George Tucker, Carl Montgomery, Pattie Duffy, and Mike Bruni. This photograph was taken at the old school in Apalachicola before Chapman High was built. (AML.)

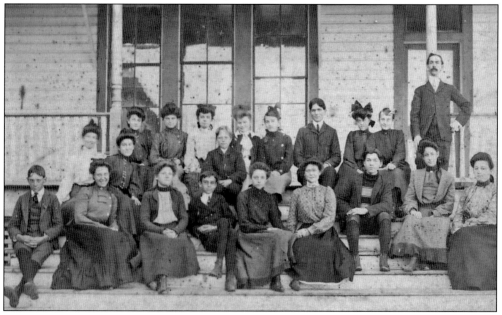

This class of students from Chapman High School is pictured in the late 1890s. Their alma mater went: "Dear old Chapman, the school of our dreams; We will always look up to your teaching. We'll honor the blue and the gold, And your standards we'll all uphold. When we get discouraged and sad, We will think of our high school days at Chapman, And these thoughts will make us so glad, Because we'll always love and trust you, dear old Chapman." (DPH.)

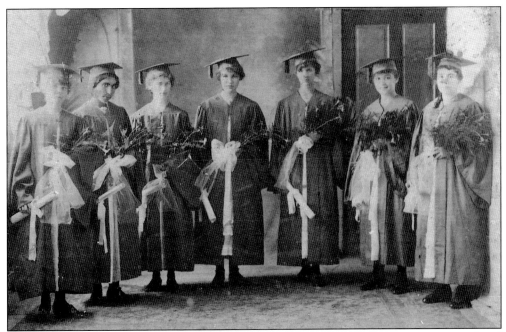

This is the Chapman High School graduating class of 1916. Fannie Clayton was principal and A. A. Core was superintendent here in June 1916. Students are, from left to right, Barbara Stovall, Madeline Totora Taranto, Florence Morris, Mamie Terry Johnson, Dorothy Sawyer Matthews, Clyde Brown, and Alice Pickett Shepherd. (DTR.)

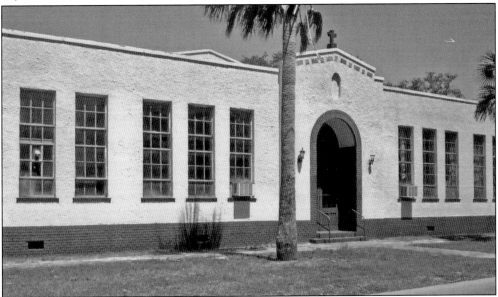

Holy Family School was established in 1920 by Bishop Edward P. Allen. Bishop Allen purchased a square block of property "on the Hill." On this property were several small houses and a large mansion. A small house was renovated and used for a chapel, and the small houses were used for a rectory. Rev. Thomas H. Massey became pastor in 1926. He built a Spanish-type all-purpose building, which was completed in 1928. The building housed four large classrooms and a large auditorium, used as a parish church. Father Massey served here for over 25 years. (BMD.)

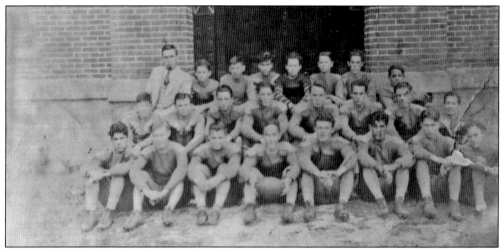

This photograph of the Chapman High School football team was taken in 1932 on the steps of the old Franklin County Courthouse. From left to right are (first row) Costa Vathis, Eldon McLeod, Arthur Calloway, Ferrell Allen, George L. Humphreys, Manuel James, Nick Nichols, and Charley Marks; (second row) Genaro "Jiggs" Zingarelli, Victor Anderson, Adolf Spear, Ed Hires, John J. "Buddy" Teague, Ivan Truman, Donald Totman, and Edward Hall; (third row) coach Wilbur Marshall, Llewelyn Truman, Murle Truman, Earl Marshall, Joseph Swilzer, George Robert Turman, John Vathis, and Charles Robinson. (AML.)

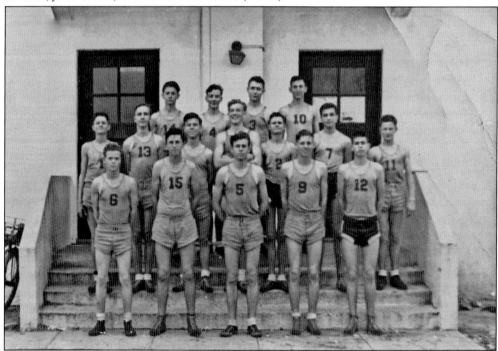

The Chapman High School basketball team included the 10th, 11th, and 12th grades from 1942 to 1946. From left to right are (first row) Fred Fitzgerald, Ryan "Sonny" Counts, Leon Tucker, Quinton Herndon, and Sherwood "Slick" Edwards; (second row) Billy Howell, Joel Gainous, Verlon Owens, Calvin Anthony, Bobbie Howell, Fred Scott, and Charles Brass; (third row) Dolphus Maxwell, Robert Gwen, Robert "Bobby" Marrs, and Dwight Marshall. (AML.)

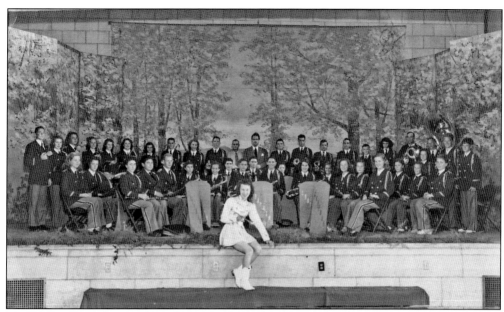

The Chapman High School Band played many tunes throughout the 1946–1947 school year. The lady in front is Geraldine Watkins. One of their school cheers by Marjorie Weems went like this: "Mashed potatoes, rutabagas, sweet potatoes, squash, Chapman, Chapman, Yes By Gosh!" It was taken from the class of 1934. (DPH.)

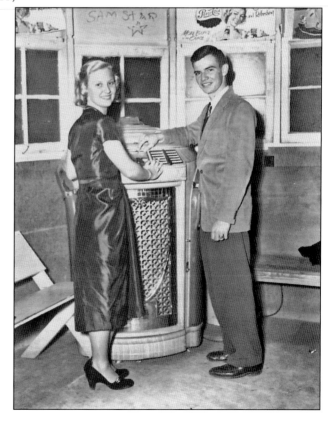

TURN-IN was a local business across the street from the high school where the students loved to hang out. Later the business closed and the building was moved out on Brownsville Road. Here are seniors Fred B. Sawyer and Dorothy Rose Matthews standing at the jukebox during the night of the 1953 Christmas party. (FS.)

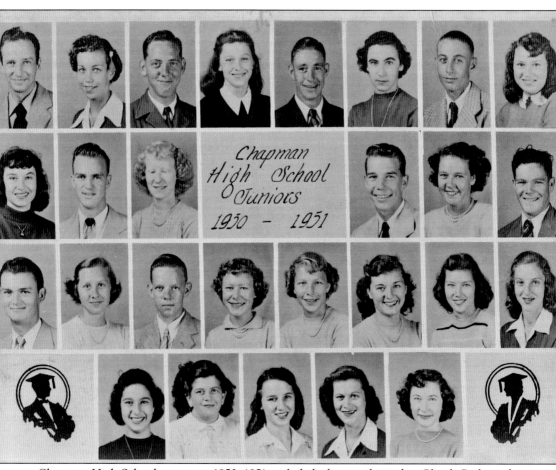

Chapman High School juniors in 1950–1951 included, along with teacher Claude Paskins, from left to right, (first row) Paskins, Dorothy Jean Marshall, Franklin Bohannon, Eunice Harris, George Martina, Neda Taranto, Richard Bloodworth, and Miriam Bouington; (second row) Mary Joyce Marshall, Fred Cooper, Geneva Tharp, Billy Ayers, Nellie Ramsey, and Ward Smith; (third row) Donnie Lanier, Shirley Norman, Frances Peddie, Faye Polous, Myrna Boyett, Selma Peters, Coleen Cook, and Shirley Siprell; (fourth row) Margie ?, Nancy Clark, Ruth Hall, Rachel Johnson, and Florence ?. (RHS.)

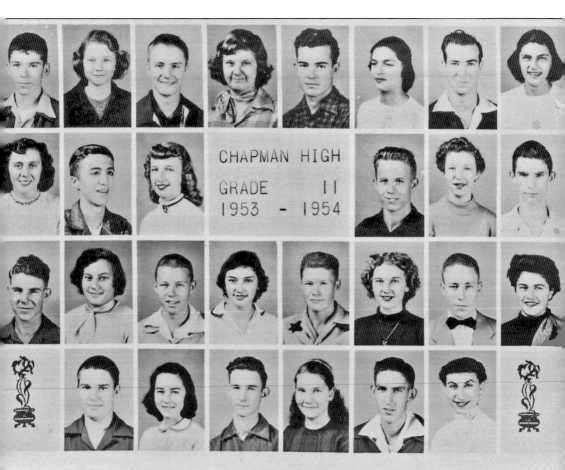

Pictured here from left to right is Chapman High School's 11th-grade class of 1953–1954: (first row) Bobby Kirvin, Annetta Holland, Dickie Porter, Shirley Busby, Rudolph Buzier, Marilyn Stabe, Bobby Rabon, and Eleanor Stabe; (second row) Ida Owens, Johnny Howard, Ruthie Jean Brogdon, Tommy Gordon, Mary Nell Trest, and Kim Sawyer; (third row) David Paul, Merle Davis, Donnie Crum, Frances Stevenson, Gayle Smith, Yvonne Collins, Vernon Griner, and Ferdie Nolan; (fourth row) Glenn Totman, Connie Allen, John Joe Buzzett, Geneva Gordon, Hoyt Thompson, and Dolores Taranto. (DTR.)

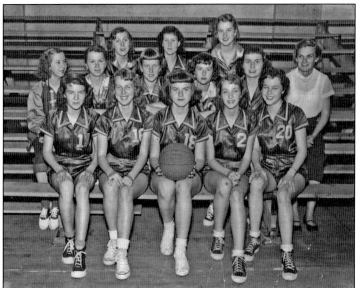

The 1953 Chapman High School girls' basketball team included, from left to right, (first row) Doris Jean Freeman, Myrna Melvin, Shirley Siprell, Patsy Baxter, and Shirley Watkins; (second row) Mary Nell Trest, Jenny Sue Freeman, Sally Nash, Mary Sharit, Kathleen Varnes, and coach Merla Robinson; (third row) Zora Lee Alford, Ida Owens, and Yonne Collins. (BAB.)

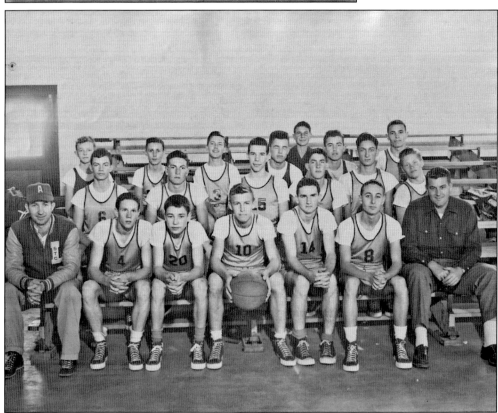

In 1951, the Chapman High School boys' basketball team was, from left to right, (first row) coach Bill Wagoner, Red Davis, Joe Worden, Luvern Lashley, Jackie McNeil, Dickie Bloodworth, and coach Joe Pope; (second row) Fred Sawyer, Buddy Ward, Billy Ayers, Hoyt Thompson, Bobby Carrin, and Charles Smith; (third row) Richard Meyers, Tommy Patton, Harry Folk, Rudolph Buzier, Adolph Buzier, and Bobby Stokes; (fourth row) David Paul. (FS.)

Six
Tour of Homes and Historic Landmarks

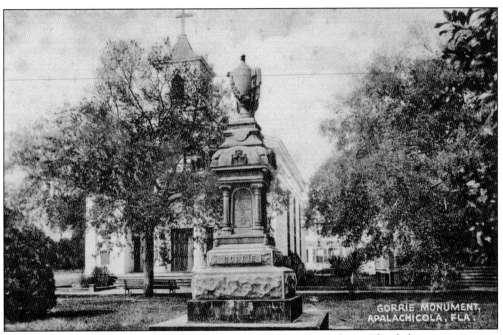

This is the burial place of Dr. John Gorrie, inventor of the ice machine. The dedication ceremony was held on April 30, 1900. George H. Whiteside of the Apalachicola Ice Company coordinated the memorial that paid tribute to Dr. John Gorrie (1803–1855), an antebellum physician and inventor. Seeking aid for his Apalachicola yellow fever patients in the 1840s, Gorrie invented a rudimentary refrigeration machine that produced artificial ice. He obtained a patent in 1851 but never realized his dream of developing the machine before his death four years later. Whiteside raised money in the 1890s to erect a white bronze memorial, 5 feet in height, in front of Trinity Episcopal Church. Inscriptions on the monument's panels list the dates of Gorrie's life, his famous invention, and a depiction of the physician as "a pioneer who devoted his life to the benefit of mankind." (FC.)

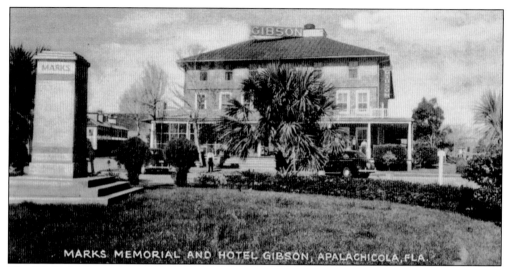

The Marks Monument was placed in the center of downtown Apalachicola. It stands here in remembrance of Lt. Willoughby Ryan Marks, who commanded Company C of the 61st Infantry, 5th Division, for showing "extraordinary valor" and sacrificing his life in an attempt to save a comrade killed in the Argonne, a World War I battle fought October 12, 1918. Marks was honored in the naming of the local American Legion Post. (AML.)

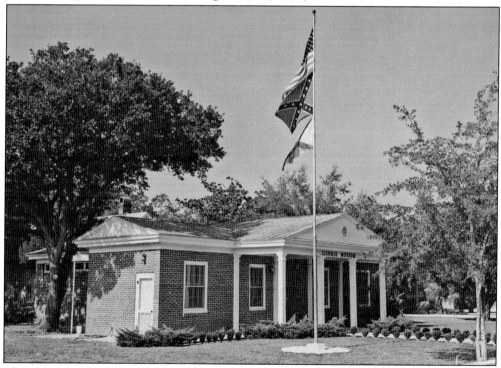

The John Gorrie Museum contains a replica of the ice machine created by Dr. Gorrie. His invention later became the basis for the ice industry and air-conditioning. Gorrie received the first U.S. patent for mechanical refrigeration in 1851. Other exhibits chronicling the colorful history of Apalachicola can be seen here. These items all played an important role in Florida's economic development. The museum is located on Sixth Street in Apalachicola. (AML.)

Chestnut Cemetery dates back to the 1830s, with its hand-forged fences and exquisitely carved headstones. It is one of the most significant cemeteries on the Gulf Coast. Interred here are many of the founders and creators of Apalachicola's colorful history. These gravestones mark the socioeconomic, ethnic, and religious diversity of early Apalachicola. (AML.)

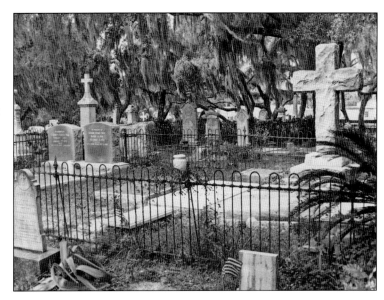

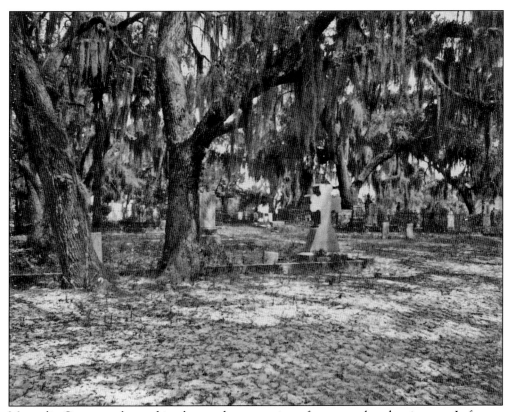

Magnolia Cemetery, located in the northwest section of town, replaced a site near Lafayette Park in the southwestern section of the city where many early settlers were buried. When the land near Lafayette Park became valuable because of its location, officials moved the remains to Magnolia Cemetery. (AML.)

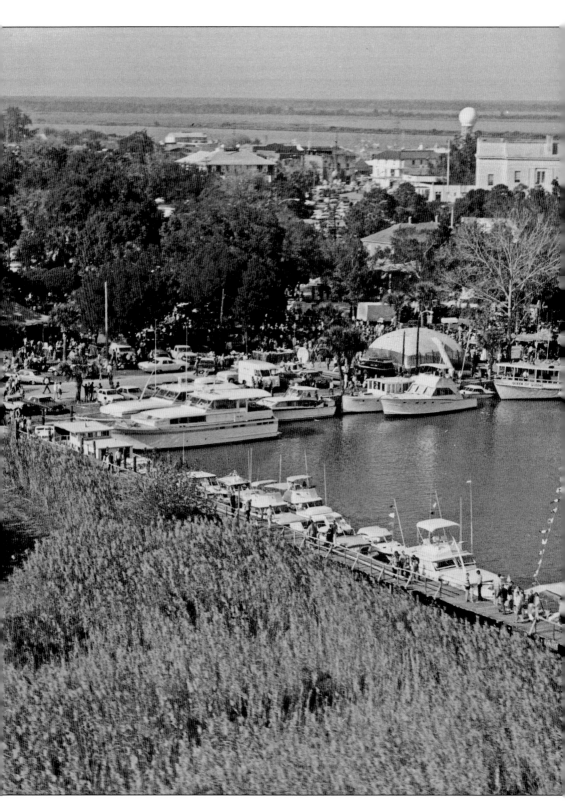

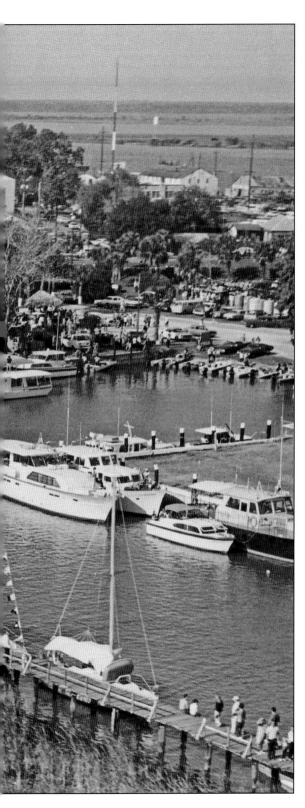

The City of Apalachicola has a variety of resource-based activities because of its geographic proximity to the Apalachicola River and Bay. The city's two largest parks, Battery Park and Lafayette Park, are both waterfront parks. Battery Park, located beneath the John Gorrie Bridge at the entrance to Apalachicola, is the site of the annual Florida Seafood Festival. The city has an agreement with the Florida Seafood Festival, a nonprofit organization, to manage the city-owned marina at Battery Park. With the planned expansion of tourism in Apalachicola, it is expected that the private sector will increasingly be a provider of recreational facilities. This park features a new community center and children's play equipment. Recreational sites provide opportunities for picnicking, hiking, hunting, water sports, fishing, or simply enjoying nature. (AML.)

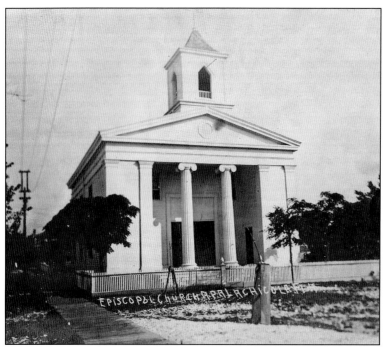

Apalachicola's Episcopal Trinity Church was prefabricated and brought down from New York in 1839 on three schooners. Organized as Christ Church in 1836 and renamed Trinity in 1857, this building was shipped in sections of white pine by schooners and assembled using wooden pins. The columns at the entrance were handcrafted on-site. It was listed on the National Register of Historic Places in 1972. (LZ.)

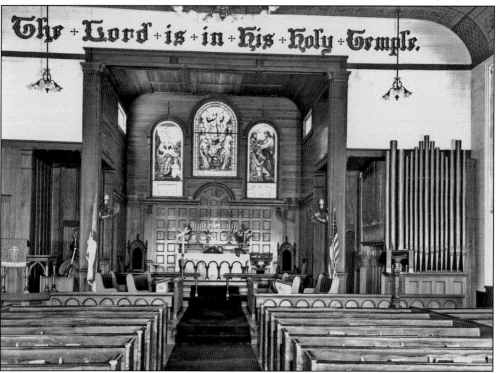

The interior of the Trinity Church's Greek Revival qualities illustrated the grandeur of Catholic Revival. Painted on the wall behind the altar were cloudbursts outlined in gold-leaf paint. A complete set of altar cloths, two brass vases, and two chancel chairs were donated in June 1887. Three stained-glass windows and a new organ were added in 1921. (DPH.)

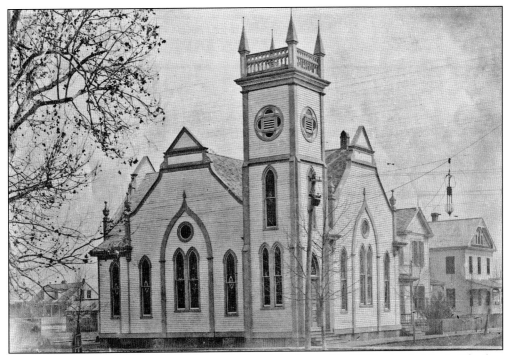

St. Paul African Methodist Episcopal (AME) Church is pictured in 1918 in Apalachicola. The first church built here was a wooden structure in 1866. Emanuel Smith was chairman of the Steward Board when the first church was built. As of today, there have been three churches constructed on this site. Officials borrowed money from the Cypress Lumber Company to construct the second church, also of wood, in 1892. (LZ.)

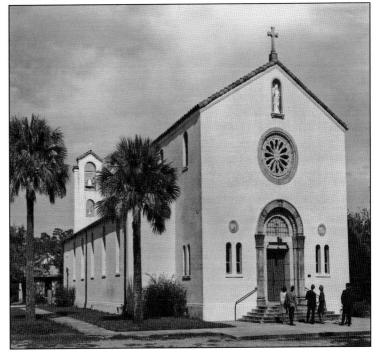

St. Patrick's Catholic Church was organized in 1845 by Rev. Timothy Birmingham. The congregation originally met in an ornate structure with elaborate interior stencil work. The church was replaced in 1929 by a Romanesque building. This church serves a number of Irish, Italian, and other families. The church building at 27 Sixth Street was restored and rededicated in 1994 and remains one of the town's most distinctive landmarks. (FS.)

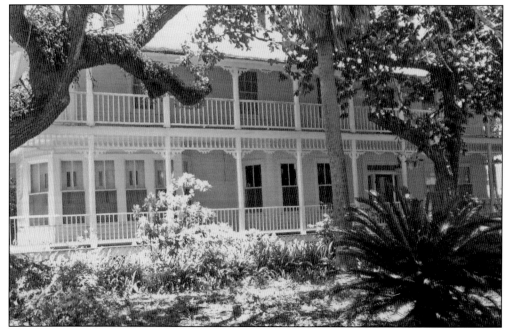

Robert Myers built the original part of this house around 1849. Henry Brash acquired the home in 1865, and he and his family grew up here. In the late 1880s, his son Solomon, an employee of Coombs Lumber, turned the house 90 degrees, added a second story, and extended the veranda around all sides. Known locally as the Porches or the Steamboat House, this distinctive residence is on the Florida Jewish Heritage Trail. (BMD.)

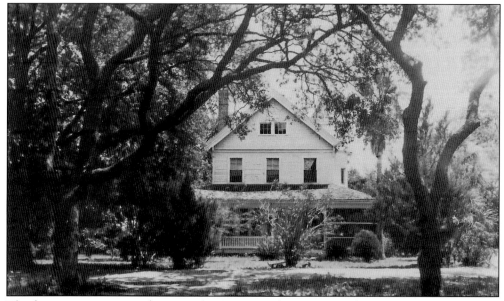

This house was constructed in 1894 for August Mohr, superintendent of the Cypress Lumber Company. The builders were George and John Marshall, who provided the "Carpenter Gothic" filigree decorations. Named Villa Rosa in the 1920s, the house was purchased by writers Alexander and Margaret Key in the late 1930s. After the Keys divorced in the mid-1940s, Margaret Key continued to live in the house until her death in 1996. (FC.)

Weems Memorial Hospital was built in Apalachicola in 1959. The county-built hospital carries the name of Dr. George Emerson Weems, who began his medical practice in Apalachicola in 1909 in the rear of Robbins Drug Store. Dr. Weems exemplified the role of country doctor by seeing many patients in their home, and his dining room table was used for late-night emergency surgeries. (LG.)

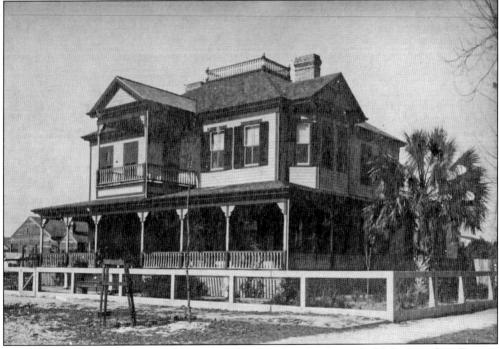

John Wesley and Rosalie (Hawkins) Wakefield, their five daughters, and John's mother, Frances B. Wakefield, lived here. The Marshall Brothers built this Queen Anne–style house in 1906. After John died (in 1936), Rosalie continued to live on in the house, later dying in 1953. The place was kept up by the Wakefield daughters Rosalie and Muriel. Rosalie died here in 1997 at the age of 101. (WC.)

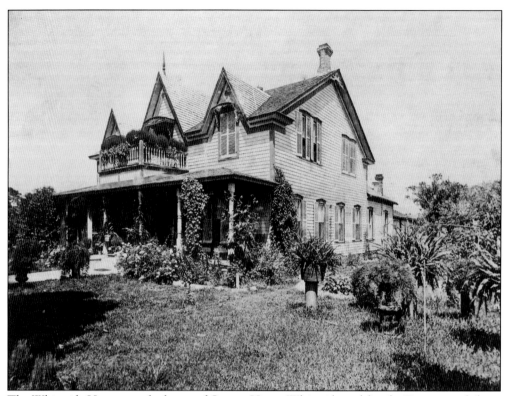

The Whiteside House was the home of George Henry Whiteside and family. Constructed about 1878, it was located at Avenue D and Twelfth Street. Later it became the home of E. Nesmith. Today photographer Richard Bickel lives here. (ABCC.)

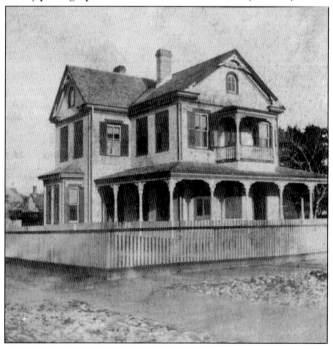

The home of George H. Ruge, co-owner with his brother John of an oyster canning business, was built around 1897. The home was designed by Lockwood Brothers of Columbus, Georgia, based on a photograph of a newly constructed home in New York. Over 100 years later, this residence is still the same—even the paint colors have been maintained—as when it was built. (RHS.)

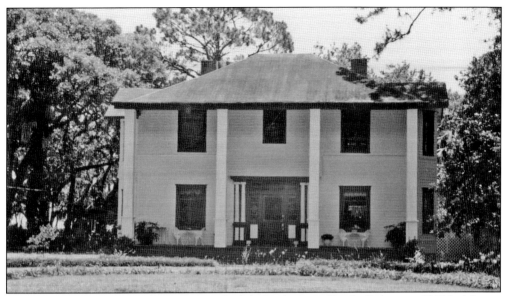

Barefield/Holy Family/Schoelles Home was built by lumberman Charles Dobson in 1907 for Minnie Barefield, a mulatto lady who lived there until her death in 1917. The house had beautiful stained-glass windows, eight fireplaces, imported tile, and carved mantels. Sisters of the Holy Family used the 14-room two-story mansion as a convent-school. In 1974, it was sold to the Schoelles, and they moved it to the bay. (RHS.)

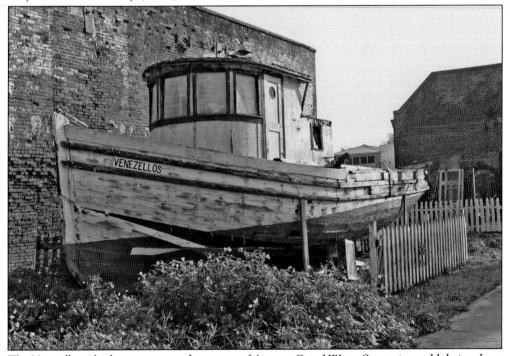

The *Venezellos*, which now rests on the corner of Avenue C and Water Street, is an old shrimp boat that recalls the days when shrimping was an important part of the local economy. Built by a Greek American, Demo George, it has a classic design. George, who named many of his boats after his children, named the *Venezellos* in honor of Greek prime minister Eleftherios Venizelos. (DW.)

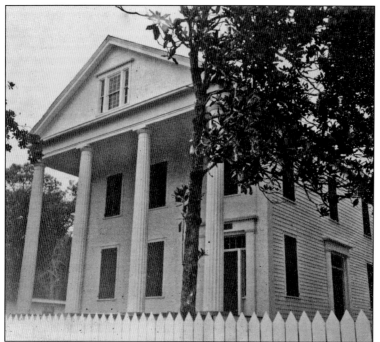

The Raney house was completed in 1838 in the Greek Revival style by David Greenway Raney. Raney made his fortune in the cotton trade and served two terms as mayor. Judge George P. Raney's family lived here; he was a lawyer and was chief justice on the Florida Supreme Court. The City of Apalachicola purchased it in 1973 and established the Raney House Museum, operated by the Apalachicola Bay Historical Society. (AML.)

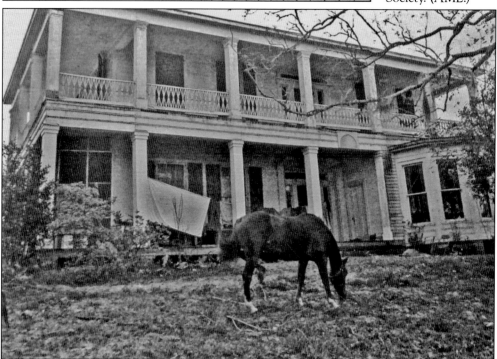

The Orman house, built in 1837, stands on an elevation overlooking the Apalachicola River. This was the home of Thomas Orman and family. During the Civil War, when Confederate soldiers were home on furloughs and saw a large keg on top of the house, they would turn back because they knew Federal troops were in town. Sarah Orman used that means as a warning for them not to enter town. (AML.)

The home of Joseph Patrick and Rebecca Hickey, known as Whispering Pines, is located out on Highway 98 toward the airport. The beautiful, old, large blue house near Twenty-fourth Street is visible today. This couple had one daughter, Lamar Hickey. The family was very active in the community, both civil and military. (AML.)

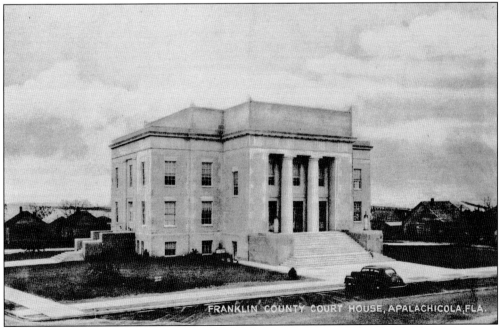

The present-day Franklin County Courthouse was built in 1947 and is the third courthouse to be constructed in Apalachicola. This one was a WPA project built in the Roman style and is prominently located in the heart of Apalachicola. (AML.)

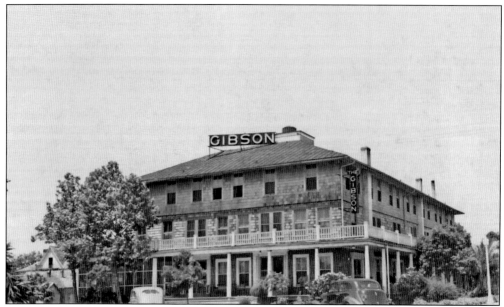

In 1923, sisters Annie Gibson Hayes and Mary Ellen "Sunshine" Gibson bought this hotel and changed the name to the Gibson Hotel. In 1925, Annie remarried and moved to Tallahassee. Her son, Edward, and his wife, Kathleen, joined Sunshine in operating the hotel. In 1983, Michael and Neil Koun and Michael Merlo bought the inn. After 23months, the early-20th-century structure was restored to its original grandeur and reopened in November 1886. (PHP.)

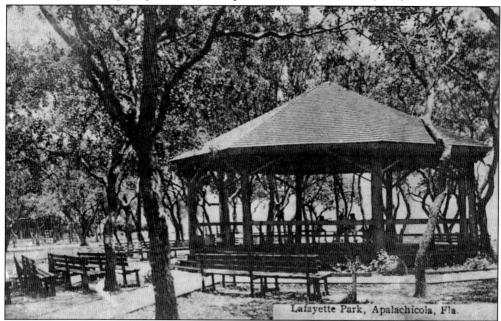

Lafayette Park, located in the center of Apalachicola's historic district, is a waterfront showcase. Dedicated in 1832 to honor the Marquis de Lafayette, it used to have a cemetery, now gone. In 1992, the City of Apalachicola and the Historic Apalachicola Foundation restored the park, adding a white gazebo, brick walkways, light posts, and children's play equipment. Today open-air concerts and weddings are held there. (FS.)

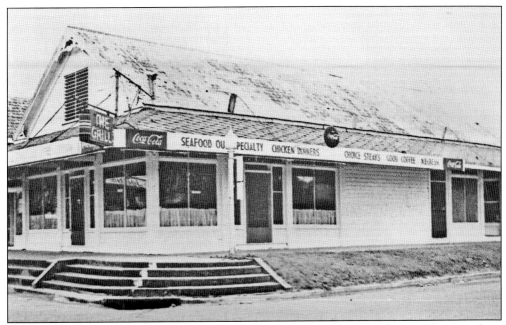

Apalachicola's the Grill was constructed in 1900, and in an earlier time, this was the spot where a fancy grocery store was located. It now has been the Grill since the 1940s. Featured in the opening scene of the movie *Ulee's Gold*, the restaurant claims to serve the world's largest fried-fish sandwich. (AML.)

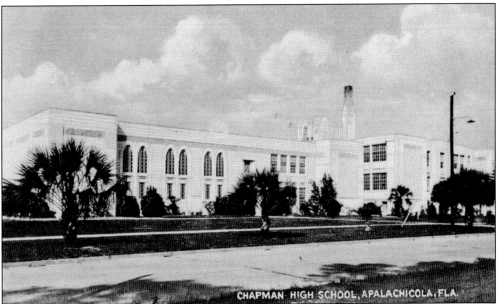

Apalachicola High School is pictured in the present day. This excellent example of Egyptian Revival architecture was designed by E. R. James in 1929. An addition to the existing brick school building (since destroyed), originally painted beige with red trim, was known as Chapman High School and changed in 1972 to Apalachicola High. Chapman High School, completed in 1934, was constructed of compressed stone and was one of the most beautiful school buildings in the state. (FC.)

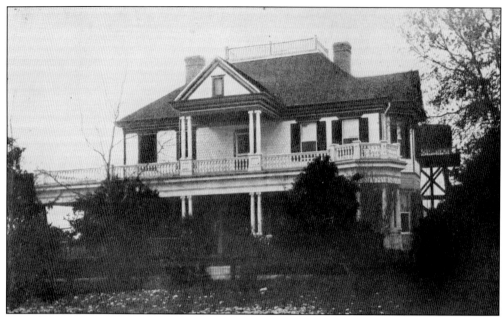

Coombs House was built in 1905 by George Marshall for sawmill owner and civic leader James N. Coombs and his family. In 1911, a fire forced the Coombs family to move to the Franklin Hotel. Within a month, both James and his wife, Maria, died, some say of broken hearts. Interior designer Lynn Wilson and her husband, Bill Spohrer, purchased the house in 1994. When renovations were completed, they reopened it as the elegant Coombs Inn. (BS.)

Built before the famous 1900 fire of Apalachicola, the old armory was named for J. Percy Coombs. It had a tower on top with a clock, along with windows up and down the stairs. After the fire, which destroyed most of the top floor, construction started again in 1901 and was completed in 1905, leaving the windows boarded up. J. Percy Coombs was an active member of the local militia and was in the lumber business. (AML.)

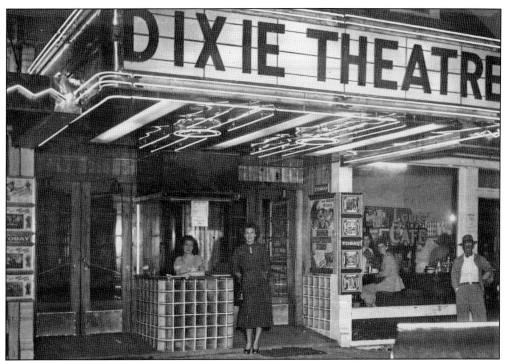

The historic Dixie Theatre opened in Apalachicola in April 1913. Built by Alexander Fortunas, the theater was a stunning addition to the town with a front marquee that glowed with more than 100 white and colored electric lights. This 1950 photograph shows the ticket girls Eunice Counts (left) and Voncille McLeod (right). Behind the counter at Louis Café, next door, are Evelyn Clark and owner George Louis. Standing outside is George's brother, Josie Louis. (DP.)

Avenue E and Water Street are home to two of the remaining 43 cotton warehouses. They were constructed in 1838 by Irish laborers and once lined the waterfront. These three-story brick buildings reflected the popular Greek Revival style of the time with French doors framed between granite pillars. Both buildings are now owned by the City of Apalachicola. This one was used as the city hall for a few years. (AML.)

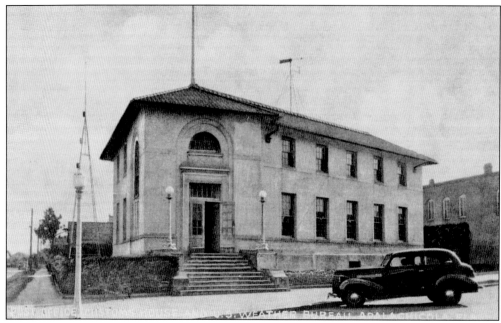

Constructed as the U.S. Post Office and a customs house in 1923, along with the U.S. Weather Bureau, it holds the original interior quarter-sawn oak paneling of this elegant building, preserved for all these past years. The building today has a rare feature for a Florida structure—a basement, as well as a tunnel that goes underground from the building to one across the street, its purpose unknown. (FC.)

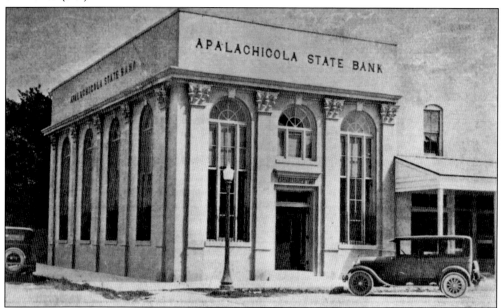

Apalachicola State Bank, which used to be the Capital City Bank, burned in the 1900 fire that almost burned all of downtown Apalachicola. In this photograph is the rebuilt bank with a new name and new look. The building today is owned by the Coastal Community Bank, with 11 branch offices throughout Franklin, Gulf, and Bay Counties. Coastal Community Bank is committed to the tradition and history of the community. (RS.)

Seven
Seafood, Lumber, Turpentine, and Bygone Years of Steam Boating

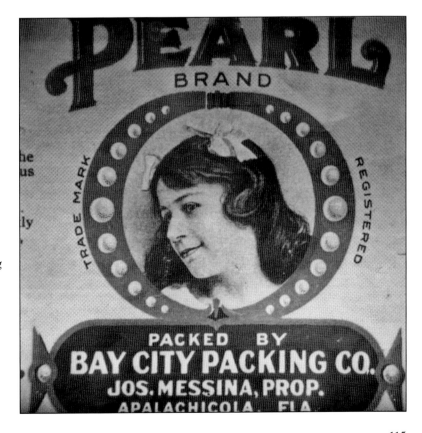

Joseph Messina took over the Bay City Packing Company in 1896, using his daughter Pearl's name as his trademark: Pearl brand oysters. Later all his products carried this name. (AML.)

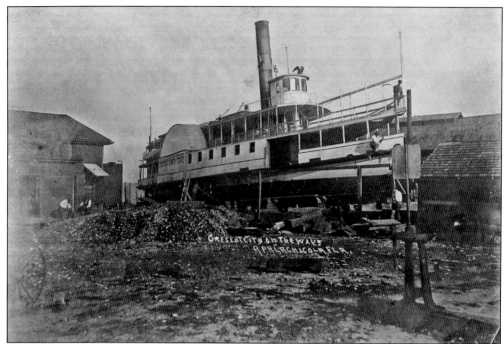

The *Crescent City* was named after Crescent City, Florida. She started life as the *Harry Hill* and the *Tourist* and was one of the first vessels of the Beach and Miller Line on the St. Johns River. The *Crescent City* was owned by the Cypress Lumber Company and was captained by Apalachicola's own Andy Wing, who reportedly made nearly 11,000 steamboat trips during his career. (FC.)

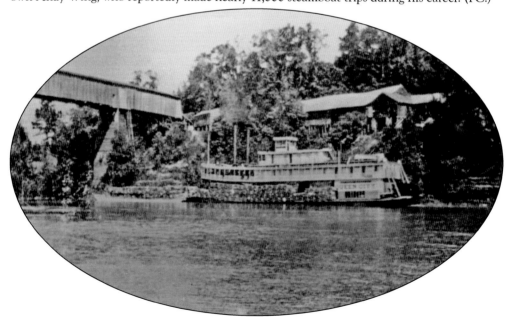

The *Queen City* was built in Columbus, Georgia, by James M. Gibbins, Charles McConnell, and George King, shipbuilders of Mobile, Alabama. Her home port was Apalachicola. She was a light-draft vessel, a stern-wheel; her owner was the Merchants' and Planters Company; and she was christened on January 20, 1891, by Mary Whiteside, daughter of Capt. Tom Whiteside. (FC.)

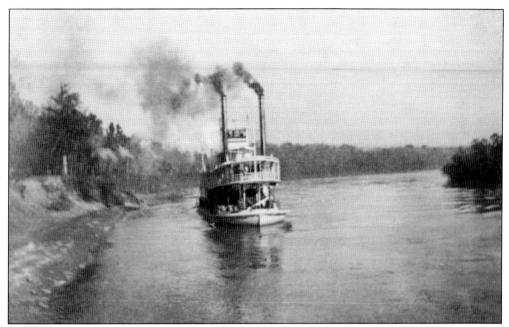

The M. W. Kelly was built in early May 1900 in Jeffersonville, Indiana, by Howard Yards. Her home port was Apalachicola. Her officers were T. A. Marcrum, master; J. M. Long, mate; C. B. Johns, chief engineer; W. A. Fry, second engineer; J. M. Bivins, purser; J. Bush, clerk; Charles Fry, steward; and James Murray, second steward. (FC.)

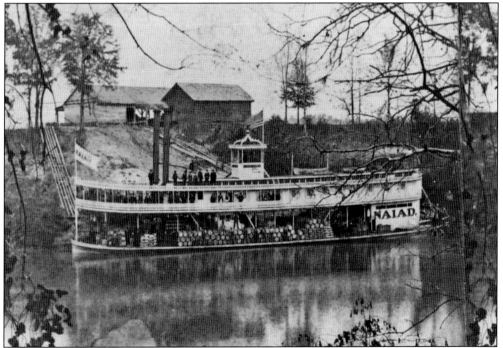

Capt. George Henry Whiteside supervised the building of the *Naiad*. She made her first trial trip to Apalachicola on September 20, 1884, from Columbus, Georgia. Originally intended as a freight boat, she had cabins added. The long-lived *Naiad*'s home port became Apalachicola. (FC.)

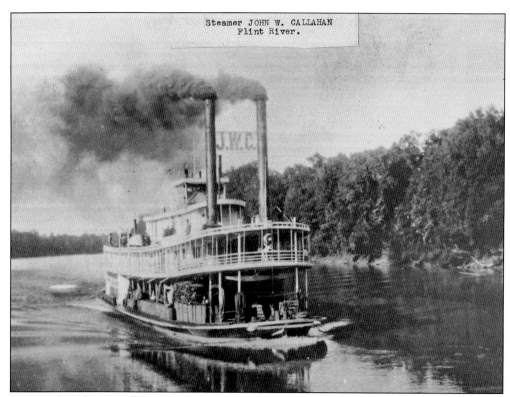

In 1907, the *John W. Callahan* was being built at Apalachicola using parts from the old *Gertrude*. Sam Johnson was her builder. Note her electric searchlights at the bow and the star and eagle decoration on the spreader bar between the stacks, as well as a fire axe on the front of the pilothouse. In command was Capt. E. L. Magruder, and her home port was Apalachicola. She was still active in 1926. (FC.)

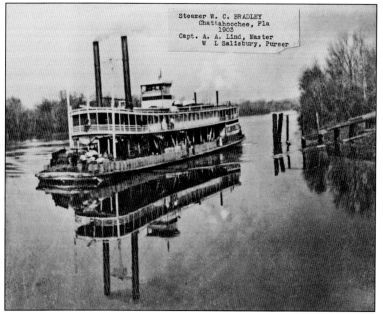

The *W. C. Bradley* was completed in October 1898 and made her short trial trip on October 31. She was owned by the Merchants' and Planters Steamboat Company, of which M. W. Kelly was president and W. C. Bradley was general manager. Capt. A. A. Lind was in command, and her home port was Apalachicola. Here she admires her reflection on the river. (FC.)

The *Lottie* was a small and powerful tugboat, propelled by steam and used to assist larger ships and to tow barges. She was owned by the Cypress Creek Lumber Company. Her first captain was Charles Marks. Capt. John Fisher died in June 1910; he had been her captain for 15 years before his retirement. In this undated picture, Capt. Dan Gillis stands at the front of the boat. (FC.)

Apalachicola and its vicinity furnish vast quantities of refuse fish that could be used profitably for oil, glue, and fertilizers. As the matter now stands, these fish are wasted because there is no way provided to utilize them. Quinn Fisheries, owned and operated by Judge Wallace M. Quinn, built a menhaden (a saltwater fish used for making fertilizer and oil) factory. (AML.)

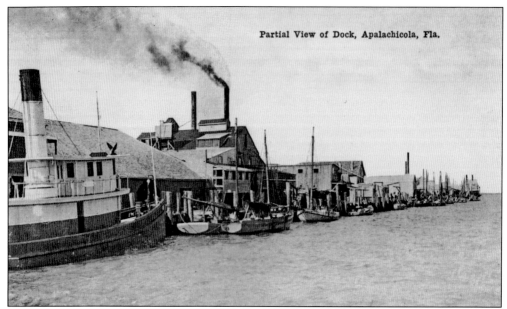

This old postcard shows a partial view of the docks many years ago in Apalachicola. It gives an idea of the waterfront conditions in Apalachicola during the steamboat times. Many warehouses and fish companies had easy excess to these docks. Notice the porgy and tugboat at the far left. (AML.)

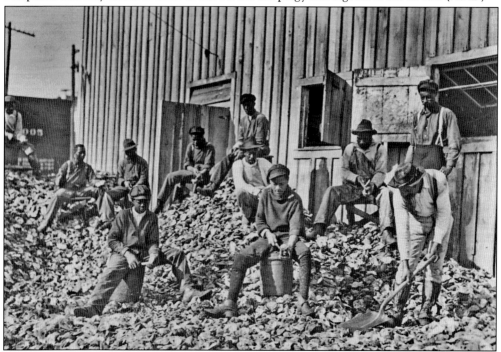

Oyster shuckers are pictured outside of C. H. Lind Oyster and Fish House in Apalachicola in 1907. Oyster season opens in September and has kept dealers busy getting ready for shipments. Apalachicola oysters are in demand on account of the excellent flavor and size. Boatmen make frequent trips to the oyster bars, and shuckers are busy shucking hundreds of gallons of oysters for shipments daily. Some 250 shuckers worked in various oyster houses on this waterfront. (AML.)

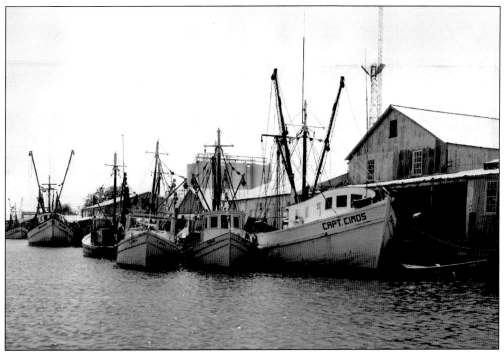

The Standard Fish and Oyster Company was founded by Demo George in the 1930s. Today it would have been where the present site of the Water Street Hotel is. The sons, Nick, James, Costa, and George, ran the business until 1970. This was one of the most successful fish houses of its day. (DW.)

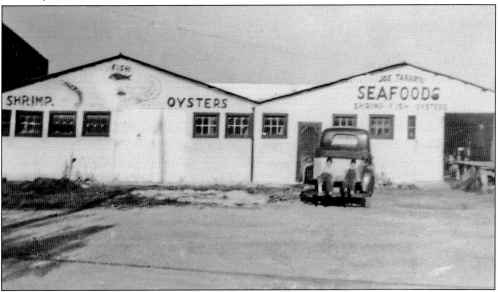

Joseph Taranto and family opened this seafood house in 1923. They employed more than 50 shuckers, most African Americans. They poured shrimp into wooden barrels, packed them in ice, and sent them to New York on trains. Joseph's son, Anthony, took over his father's seafood business and retired in 1990. Today Taranto's Seafood is closed; the building still stands on Water Street in downtown Apalachicola. This photograph was taken around 1949. (DTR.)

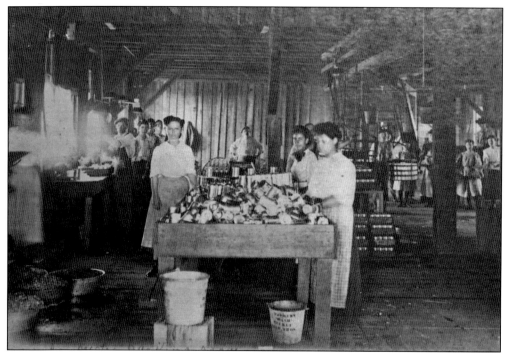

The Bay City Packing Company and Messina Cannery was owned and operated by Joe Messina, a native of Apalachicola. Messina took over in 1896 and located on Water Street, where he expanded his oyster-packing business to include a variety of profitable seafood products. Women like these were employed in the packinghouses. (AML.)

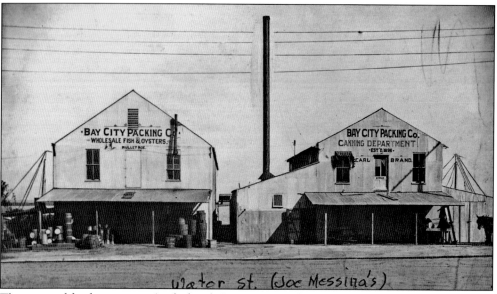

The potential for shrimping in Apalachicola Bay was not realized until the early 19th century, when local fishermen stopped discarding the shrimp they caught in their nets and began deliberately gathering them from shallow-water boats in the bay. The Bay City Packing Company began around 1915 and shipped canned shrimp to markets elsewhere. This company was owned and operated by Joseph Messina and family. (AML.)

In the early 1870s, A. B. Tripler founded the Pennsylvania Tie Company. Renamed the Cypress Lumber Company in 1882, it had headquarters in Maine and was directed locally by August S. Mohr and Uriah Morton Wright during the early 1900s. Its lumber mill operations in Apalachicola were to become the largest in the South. Wright died in 1921, and the lumber company was sold to Jerome Ship about 1927. (LZ.)

During the past 113-year history, banking has changed in profound ways—new technologies, products, and services made available in the last 10 years alone have affected the industry. Yet the Capital City way of doing business has remained constant. Walking through these doors, one can see the Capital City Bank in the early 1900s. Today they still bank on knowledgeable, caring, and nice associates to help customers with their financial needs. (AML.)

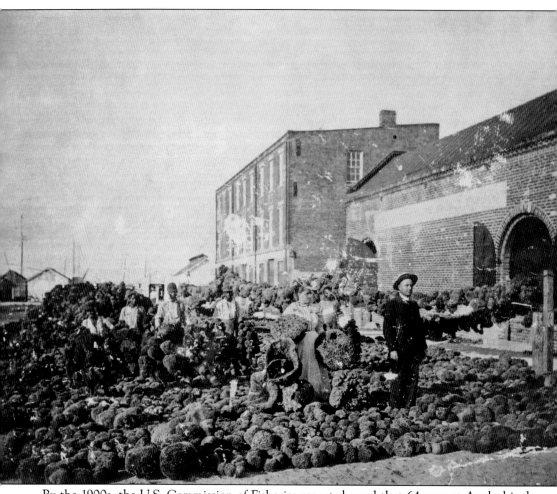

By the 1900s, the U.S. Commission of Fisheries report showed that 64 men at Apalachicola were employed in the sponge industry. Several varieties of sponge were found off Florida's Gulf Coast: yellow, grass, wire, and the most valuable, sheep wool. Apalachicola became involved with the discovery of sponge beds in the reefs off Dog Island. The sponge industry evolved from men wading into shallow waters and plucking the sponges to more sophisticated methods as sponges were found in deeper waters. By 1879, local seafood men outfitted ships for expeditions for up to a month. A mother ship, where the sponges were cleaned and strung up to dry and then stored below, carried several 12-foot-long rowboats whose two-man crews took the sponges by hooking them. As late as 1900, a dozen or more sponge boats still operated out of Carrabelle and Apalachicola. (AML.)

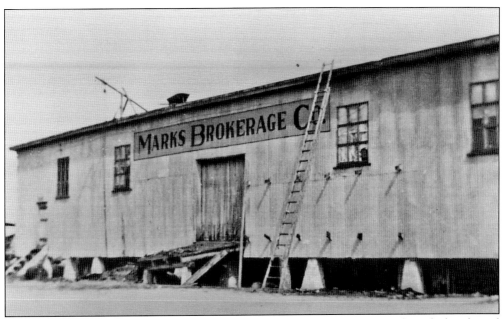

Marks Brokerage Company, since before 1915, supplied most business around Apalachicola and nearby communities. Marks has groceries, hardware, and much more. This metal building is part of their warehouse. Written on the back of this photograph, signed by Homer Marks, is, "I was repairing the leaks on roof when this photograph was snapped about 1940. The building is 200' long, 60' wide w/a 200' wide w/ an 18' by 200' dock on riverfront." (ABCC.)

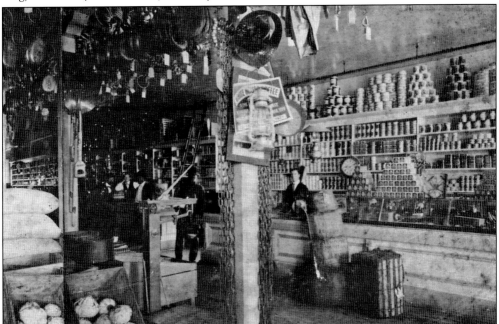

Pictured here is the interior of the J. E. Grady and Company hardware store and ship chandlery in the late 1800s. The family-owned business specialized in supplying cargo ships and steamboats, which tied up to the Water Street docks in front of the store. A destructive fire in 1900 destroyed much of downtown Apalachicola, including the original Grady building. (ABCC.)

Tommy Ward's life is oystering, just like his father, uncles, cousins, and grandfather. Here he is standing near his boat behind the oyster house at 13 Mile. Tommy learned everything from his father, Buddy Ward. He can tell about the shucking machines, the packing room, the canning machine, the icehouse, and the oyster dredge. Tommy now operates Buddy Ward and Sons Seafood and Trucking, Inc., and Thirteen Mile Oyster Company. (MMW.)

Apalachicola Bay is best known for its oyster harvest, but the harvest of seafood in general has been an important business here for years. In the 1918–1919 season, about 200,000 gallons of fresh oysters were shipped and there were over two million cans of packed oysters sent away. Until recently, between 60 and 85 percent of the citizens of Franklin County have made a living from the seafood industry. (AML.)

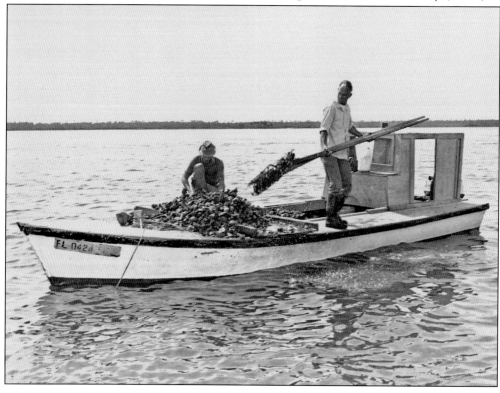

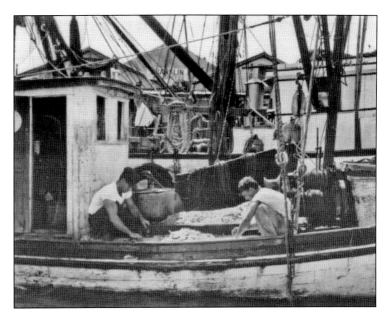

Franklin Fish and Oyster Company was operated by Belton Tarantino just after World War II. He later started the processing of blue crabs. In this photograph are Bill Martina (left) and Pete Poloronis (right), culling shrimp on deck of the *Nora B* around 1952. All the Poloronis, Martina, and Tarantino families were in the seafood industry around Apalachicola. (DJP.)

Christo Poloronis is a well-known figure in Apalachicola. He is the son of Stratis and Josephine Poloronis. An oysterman, fisherman, and just an all-around good guy, Christo has worked for most of the fish houses around Franklin County. Today one can find him riding his bicycle anywhere around Apalachicola. (DJP.)

Discover Thousands of Local History Books Featuring Millions of Vintage Images

Arcadia Publishing, the leading local history publisher in the United States, is committed to making history accessible and meaningful through publishing books that celebrate and preserve the heritage of America's people and places.

Find more books like this at
www.arcadiapublishing.com

Search for your hometown history, your old stomping grounds, and even your favorite sports team.

Consistent with our mission to preserve history on a local level, this book was printed in South Carolina on American-made paper and manufactured entirely in the United States. Products carrying the accredited Forest Stewardship Council (FSC) label are printed on 100 percent FSC-certified paper.